The Historical

SOURCE BOOK
FOR *Scribes*

Michelle P. Brown & Patricia Lovett

UNIVERSITY OF TORONTO PRESS

Cover:
Details from The Vespasian Psalter, BL, Cotton MS Vespasian A. i, f. 110.
 The Lindisfarne Gospels, BL, Cotton MS Nero D. iv, f. 208.
 BL, Cotton Ch. Aug. II. 61.
 BL, Harley MS 2797, f. 43.
 The Ramsey Psalter, BL, Harley MS 2904, f. 122v.
 The Grimbald Gospels, BL, Additional MS 34890, f. 107.
 The Bedford Hours, BL, Additional MS 42131, f. 183.
 BL, Royal MS 16. G. III, f. 8.
 BL, Additional MS 28025 f. 137v.
 The King's Virgil, BL, King's MS 24, f. 15.
 BL, Royal MS 12. C. viii, f. 6.
 The King's Virgil, BL, Kings MS 24, f. 131v.

First published 1999 by
The British Library
96 Euston Road
London NW1 2DB

Published in North and South America in 1999 by
University of Toronto Press Incorporated
Toronto and Buffalo

British Library Cataloguing in Publication Data
A catalogue record for this title is available from The British Library

ISBN 0-8020-4720-3

Designed by Hernewood Studio
Printed in Hong Kong

Contents

Index of manuscripts cited

Author's note:

Punctuation, Arabic numerals and an ampersand have been included for all the alphabet styles even though these were not used in the earlier hands.

A dotted line as a direction stroke on the pages showing how to write the letters in each alphabet style indicates that the left-hand corner of the nib is used for hairline strokes.

In creating the artworks showing each alphabet style especially for this book I have attempted to keep to the spirit of the historical scripts, both in the letter-forms and in the choice of subject matter which has been written out. Tempting though it has been at times, I have tried to maintain the original letter shapes without distortion or personal interpretation (apart, for clarity, from changing the long letter **s** in certain manuscript styles). *Patricia Lovett*

Introduction

Michelle P. Brown

Why should we be interested in studying early hand-written and decorated books? For me they are one of the most direct ways of linking past, present and future, for they are essentially about people and yield a wealth of information concerning their lives, beliefs and aspirations and symbolise our essential human need to communicate this information across time and space. This is true of most forms of human communication, but the hand-produced book is a particularly holistic artefact, in which intellectual and creative endeavours can be viewed against the socio-historical circumstances of their production – the factors governing those who commissioned, created and used them. In this respect each volume is rather like an archaeological excavation, offering up a vast amount of fascinating detail and fitting together with other evidence to give a deeper understanding of its age. Like many such sites, one often feels the need to visit them in person – to wander through the shop-lined streets of Pompeii or to ride through the "...rose-red city – 'half as old as time'" that is Petra. But manuscripts are even more fragile than such places and if we are to preserve them for future generations our own access to them must be exercised extremely judiciously, with the aid of exhibitions, publications (electronic and conventional), study days, conferences and seminars. Handling of the originals, as with any such artwork, must be contained if we are to continue to enjoy them in the future.

Whatever form of access to these precious materials one has, their study is worthwhile and can both inform and fuel the creative process. Calligraphers and palaeographers can learn a lot from their respective viewpoints. To understand how something was done is an important part of discovering why it was done, and the practical experience of the contemporary scribe and illuminator can help to inform the palaeographer in an historical assessment of script. Conversely, the aesthetic appeal of such works can be greatly enhanced by knowing something of the circumstances in which they were produced. Sometimes we even know something of the lives of

the scribes themselves and of the works from the past which inspired them.

It is this combined approach that is explored in the present work, in which I set the scribes and their scripts in context and Patricia Lovett analyses the way in which the manuscripts were produced and the materials used, with the aid of illustrations and her own artwork in the form of diagrams, exemplar letters and creative calligraphy all produced specifically for this book.

Being able to reproduce these historical scripts is not, however, an end in itself. We hope that understanding something of the motivation which fired these scribes to produce some of the West's most beautiful scripts, and examining how they achieved them, will inspire you to use them as a springboard to create new works which are also of their age and which can take their place in that chain of creativity which extends throughout time and space.

Patricia Lovett and I should like to take this opportunity to acknowledge a debt of gratitude to the following:

To palaeographers such as Elias Avery Lowe and Julian Brown, whose sensitivity to the work of contemporary scribes informed their study of historical scripts.

To scribes such as William Morris, Edward Johnston, Graily Hewitt, Sheila Walters, Ewan Clayton and Stan Knight, whose work has been inspired by their appreciation of earlier scribes and scripts.

To our families, friends and colleagues.

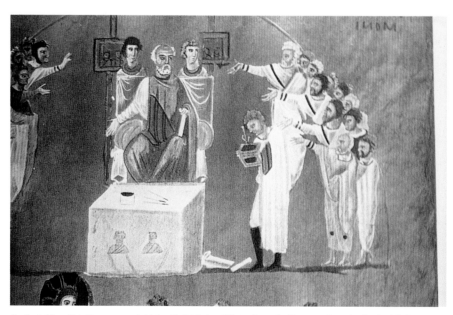

Scribe taking dictation on wax tablets. Christ before Pilate, from the Rossano Gospels. Syria, 6th Century.
Rossano, Il Duomo di Rossano, Rossano Gospels, f. 8v.

Tools and Materials

Patricia Lovett

Calligraphy, the art of beautiful writing, shown to great advantage in manu-scripts from the British Library and other great collections, is a wonderful skill to acquire. Almost all of the alphabets which are used by today's scribes are based on those from earlier times and without doubt one of the best ways of learning calligraphy is to study historical scripts. Of all the arts and crafts calligraphy is one of the most easily accessible, as you need so few essential items to start – something to write with, and something to write on.

Early scribes had a much more difficult task than we have now. The writing surface, generally parchment or vellum, had to be prepared from animal skin; the pen, cut from a reed or from a goose, crow, raven or swan's flight feather, needed frequent re-cutting; and ink was ground from soot or made from oak galls then mixed with gum. Modern scribes can buy inexpensive paper, bottled ink and manufactured pens usually all from the same shop.

Although starting calligraphy may be easy because of the relative availability of the tools and materials, choosing what is right for you is a little more chall-enging. The better-quality pen, ink and paper will usually give you a more satisfactory result, although it is not always worthwhile using very expensive paper simply for practice. Many scribes use different types of pens at various times – felt tip pens for roughs and planning out projects, metal pens for some finished pieces and quills for others.

Pens

Quills made from the first five flight feathers of a goose, swan or turkey still provide the most responsive writing implement and writing with a quill on well-prepared vellum is one of the most rewarding experiences. Making quills is not difficult, although perhaps a little time-consuming, and they also need sharpening regularly, which can become a chore.

For all birds, the first five flight feathers provide the best quills, although my choice is the first three. The first feather, which has a short but hard barrel, is called the *pinion*. It is distinguished by having very short barbs along the leading edge of the feather, that is, the edge on the bird's wing which is exposed to the wind. The second and third feathers are both called

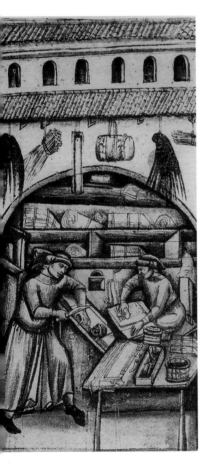

Bundles of quills and wings hang outside a fifteenth-century stationer's shop in Bologna. Inside the shop the man on the left is trimming a sheet of vellum to size using a sharp knife, and on the right-hand side writing is being erased from another sheet of vellum.
Biblioteca Universitaria, Bologna, MS 1456, f. 4.

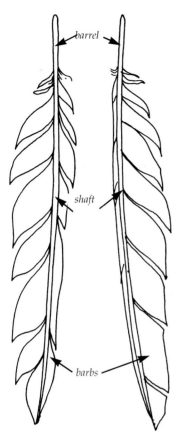

Feathers from a bird's right wing curve naturally to the left and so are best suited to left-handers. Those from the bird's left wing curve to the right and so away from the body when used by right-handers.

A dutching tool can be made from a brass cup hook. Hammer out the curve of the hook until it is straight. File the hook so that the underside is flat and goes to a blunt point, and insert the hook into a handle for protection from heat.

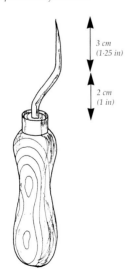

3 cm
(1·25 in)

2 cm
(1 in)

seconds; they have longer barrels but are not so hard. The barbs on seconds are narrow along the part of the shaft where they are exposed, but longer where they are overlapped by the pinion. The fourth and fifth feathers which have long but narrower barrels, are both called *thirds* and there is little narrowing of barbs on one side. Because of the way they shape around the body of the bird, feathers from the left wing are better for right-handers, and those from the right wing for left-handers. Swan, goose and turkey feathers are chosen by modern scribes for their quills. Swan barrels are long and wide; goose barrels are shorter and narrower; turkey barrels are shortest of all, but tough. When selecting feathers to be cut into quills, choose the type and shape of feather which is most suited to your needs.

For the earliest codices it is likely that reed pens were used. Reeds make good pens although they are rarely used for very small and delicate lettering. There is little evidence to suggest that feathers were used much before the sixth to seventh centuries. Isidore, Bishop of Seville (560–636) writes in his *Etymologia*, '*Instrumenta scribe calamus et penna*' – 'the instruments of the scribe are the reed and quill'. Reeds are cut similarly to feathers (*see* page 10), but do not require pre-hardening.

Feathers must be hardened or cured so that the soft, milky-white barrel of a fresh feather becomes hard enough to produce the sharp edge required for a good quill, and so that the two sides of the cut nib do not splay when used for writing. It is important that the grease is removed, too. This happens when the feathers are left for some years or when heat is applied. Early scribes probably allowed feathers to mature naturally so that they hardened over time. Nowadays we do not usually want to wait three or more years for feathers to harden, so we do this artificially with heat. This can be done by simply pushing the barrel of the feather into a fire. It is a little risky though, as the barrel shrivels with too much heat, and repeated short tests inserting and checking the feather are time-consuming. Heated sand is another way of curing feathers, but sand is not a good conductor of heat, and again there are problems of not being able to see exactly what is happening to the feather, or of controlling the process. Heat makes the opaque, soft barrel, which can often be bent in half, change to a translucent yellow or sometimes amber coloured tough material from which the pen can be shaped.

Curing or hardening feathers

Feathers were hardened by 'dutchifying' or 'dutching' from the second half of the eighteenth century. (Dutching is clarifying or hardening feathers by heat.) That process is very similar to dutching feathers now. However, nowadays a dutching tool is used which can be easily made from a brass cup hook and a wooden handle. The advantage of a dutching tool is that the process of curing a feather can be seen and controlled at all stages, as is shown on the next page. The shape of a broad-edge nib is then cut at the end of the barrel with a penknife or quill knife.

Penknives and quill cutters

It is clear from many early manuscripts that penknives were invaluable tools for scribes. With a quill in the right hand, the penknife was ready in the left to sharpen the quill when necessary and to hold down any bumpy vellum to ensure a smooth writing surface. It was also to hand to scrape away any mistakes.

The blades of almost all early penknives were curved, with one side of the

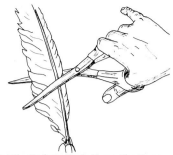

Cut the tip from the feather with scissors or a knife. Trim the feather with scissors until it is about 20 cm (9 in) or pen length.

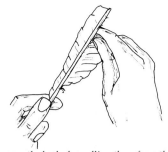

Remove the barbs by pulling them from the cut end of the feather – but cut them from the barrel so that you do not weaken it.

Soak the feathers in water for a few hours or preferably overnight. Make sure that the barrels are covered by water.

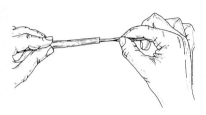

Clean the membrane from the outside of the feather with your thumbnail or the back of a scissor blade, and use a crochet hook to remove the membrane from inside the barrel.

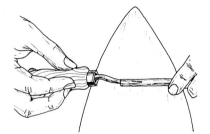

Heat the dutching tool on a warm domestic iron (wool setting or two dots). Shake the water from one feather and place it on the iron. Insert the dutching tool into the barrel of the feather and use it to hold the feather against the hot iron. Rotate the feather.

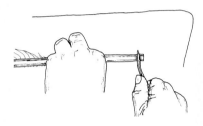

With the top of the feather uppermost place the now clear, yellowish, barrel on a flat metal surface and press hard with the dutching tool. This will squash the barrel into an oval shape and will mean that you can cut quills which have wide nibs.

Quill knives usually have curved blades, with one side of the blade ground so that it has a curve into the cutting edge, and the other ground straight.
From the Philip Poole Collection.

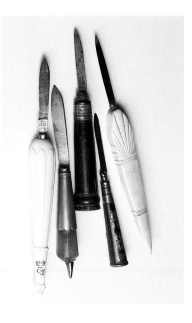

sharpened edge ground to a curve, the other straight; this made cutting the curved edge of the nib shape easier. Although penknives now are usually small folding pocket knives those for cutting quills should have a substantial handle, big enough to fit comfortably in the hand. Scalpels and similar light-weight modern craft knives are too flimsy for this purpose, and can easily slip in the hand when in use. Modern penknives are made from stainless steel which it is difficult to sharpen to a good edge. However, it is possible to cut quills with some sturdy craft knives with disposable curved blades – even though both sides of the blade are ground similarly to one edge.

Early scribes would have cut their own quills, or used those prepared by apprentices. Later, feathers were sold ready-cut. These could be recut and sharpened when necessary, but some found the process too laborious or difficult so the invention of a quill cutter designed for goose feathers was welcomed by scribes. Once the feather was hardened, the first initial scoop cut was made with a knife, and the feather was then inserted into the quill cutter. A lever was applied which pressed cutters on to the feather, shaping the shoulders of the nib, and the slit was made with a final sharp click. Most of the quill cutters were for pointed nibs, although once cut in this way the nib could be shaped to suit the writer.

Cutting a quill

Once the feather has been hardened, all that is needed to cut a quill successfully is practice. What you are doing is shaping a nib from the end of the

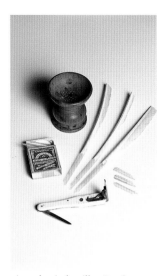

A mechanical quill cutter, 'manufactured' quill pens and quill nibs together with a pounce pot.

Below: *Cutting a quill. The same process is used for cutting reed or bamboo pens.*

barrel. Cut the end of the quill so that the shape is right for you – left-oblique if you are left-handed, square cut or straight if you are right-handed and right-oblique if you find the low nib angle required for writing Uncials with a flat nib or Half-uncials too much of a challenge.

When the writing edge becomes dull, resharpen the quill by shaving the tip again at an angle of 45° and removing the very tip to ensure the nib is cut as before. If the two writing edges of a quill separate, wrap a damp paper kitchen towel around the nib tip for a few hours.

Calligraphy dip pens

Calligraphy dip pens with metallic broad-edge nibs have flexible tips which emulate those of quills. These pens are versatile because they have nibs of different widths, allowing for larger and smaller letters to be written.

Right-handers will find it best to use nibs which are cut straight across the tip. Left-handers should use left-oblique nibs so that they do not have to twist their wrist so much to maintain the appropriate angle.

Some pen holders are fitted with a reservoir which then slides under the nib; or you may need to use a small slip-on reservoir which grips the sides of the nib, again sliding underneath. Some nibs have a reservoir attached to the top of the nib. The job of the reservoir is to feed ink to the nib. To do this the reservoir must touch the nib, and be about 2 mm (0·1 in) from the tip. If

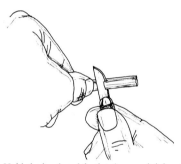

Hold the hardened feather in your left hand (right if you are left-handed) with the top uppermost. Turn the feather over and make a long scoop cut starting about 2·5 cm (1 in) from the tip, towards the tip and which goes about half way through the barrel.

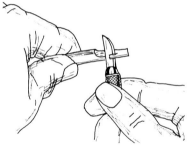

Place the blade of the knife against the side of the feather, about 1·5 cm (0·75 in) from the tip and make a cut which curves in and then goes straight towards the tip.

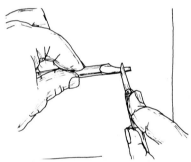

Place the knife at the point where you started the previous cut. Rotate the feather anti clockwise so that the top is underneath, and as you do so the knife will be in the correct position for making a similar scoop cut to the previous one, which shapes the nib.

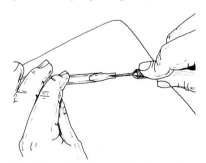

Trim the end from the quill by placing the feather – top side down – on a flat surface such as a cutting mat. Make a slit by placing the point of the knife at the centre of the nib. Press downwards until it clicks.

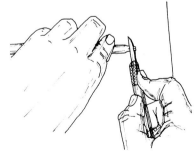

Shape the end of the nib by holding the feather on a cutting mat – top side uppermost. Place the knife at an angle of about 45° at the very tip of the nib and shave the end. This makes a bevel cut and adds a spring to the quill.

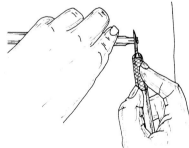

Now trim the tip to ensure that it is straight (or left or right oblique) by rocking the knife for the last nib cut. Again you will hear the click as the knife takes the smallest amount from the quill tip.

*eft-handers should use nibs which are left-
blique (shown on the left); right-handers
ill find straight cut nibs best to use (shown
1 the right).*

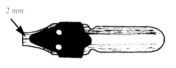

*lip-on reservoirs should be placed under
e nib so that they are about 2 mm (0·1in)
om the tip of the nib.*

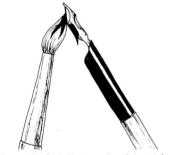

*ill a pen by first dipping a brush into ink
nd then stroking this on the underneath or
de of the nib.*

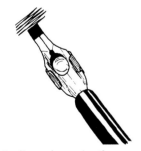

*tart a dip pen by moving the pen
ideways back and forwards making a
arrow mark. When the ink is flowing
reely then you can make wider strokes.*

it is too close to the nib tip you will be writing with the reservoir and not the nib, too far away and it cannot feed ink properly, and your writing will be laboured.

Metallic nibs may be coated with a shellac finish for protection which can cause problems when starting writing. To remove the shellac, wash the nib in warm water for a few seconds and the shellac should dissolve.

Assemble a calligraphy dip pen by choosing one of the larger nibs to start, and pushing this into the pen holder until it is secure. The reservoir can then be slid on, or adjusted so that it is in the correct position. Take care that a slip-on reservoir is not gripping the nib too tightly; on narrow nibs this may cause the two sides of the nib tip to cross over. Loosen the side grips until the reservoir slides easily on to the nib, making sure that the reservoir is touching the underneath of the nib, without pressing so hard that the nib sides are pushed apart.

Feed the ink into the pen using an old or cheap paint brush. Dip the brush into ink and simply stroke the brush on the side of the nib; the ink will collect between the nib and reservoir. This is the preferred method of filling a pen. Lazy scribes dip the pen into a pot of ink but the problem with this is that the nib may be too full with ink. There may also be a drop of ink on the nib tip which floods the first letter. If you prefer this method of filling your pen, always wipe the nib on a scrap of closely woven cloth or a folded paper kitchen towel before you use it in order to remove the excess ink.

The best letters are made with sharp pen nibs. Even when new, nibs are not always as sharp as you may want. Sharpening them is not difficult, and once you have written with a really sharp nib you will never go back to a dull one. (*See* page 12.) You will need a fine sharpening stone such as an Arkansas stone, sold in jewellery or tool suppliers; the best are almost transparent and feel very smooth to the touch. Look at the nib tip in the light after sharpening and you should be able to see the shiny metal exposed. Try writing with the pen. If it is too sharp and cuts the paper simply repeat the first sharpening stage of the nib tip to dull it and remove some of the sharpness.

Take care of your writing equipment. Slide off the reservoir and remove the nib when you have finished writing. Rinse these in water, but do so in a bowl or place the plug in the sink beforehand. Reservoirs slip away in running water as though they were alive! Dry your nibs and reservoirs on a paper kitchen towel and replace them in your pen holder when dry, or store them in a box or tin.

Calligraphy fountain pens

Calligraphy fountain pens are sold individually or as sets with units of different widths of nib tips. Because ink is supplied to the nib from a cartridge or ink reservoir, the feeding mechanism is rigid, making the nib less flexible than a dip pen. However, the fact that ink is stored inside the pen means that fountain pens are easy to use and are suitable for rough work or lettering outside your usual calligraphic set-up.

Ink for fountain pens is normally thinner than calligraphy ink and this thinness often results in show-through of strokes; it is also sold in a limited range of colours. The nibs, too, are limited in their range of sizes with few manufacturers realising that nibs of at least 3·5 mm (0·15 in) or even wider are best for beginners when starting lettering.

Use good-quality calligraphy fountain pens, with as flexible a nib as you can get, when you are starting out in calligraphy, for practice and when it is difficult to deal with a pot of liquid ink.

11

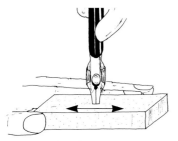

To sharpen a nib, hold the pen so that it is perpendicular and stroke the very tip along a sharpening stone 8 – 10 times to ensure that the nib is straight.

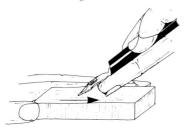

Hold a wide nib at an angle of about 35°, a narrower nib at an angle of 25°, and stroke the top of the nib 8 – 10 times along the stone.

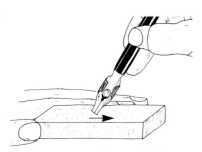

To remove any metal burrs stroke the two corners and the under side of the nib tip on the stone twice or three times each.

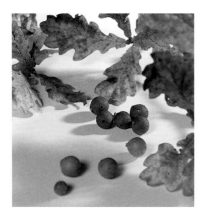

Oak galls collected from deciduous woods in Kent. Notice the holes indicating that the wasp has escaped.

Calligraphy felt tip pens

Felt tips pens are used by many beginners. They are easy to use and are available in different width tips and only a few colours and present no problems with spilling ink. However they are not usually manufactured as left-oblique tips which is a disadvantage for left-handers.

The crispness of letter-form is largely dependent on the sharpness of the pen nib or tip. That of a felt tip pen is not sharp and the resulting letters can be disappointing, but these pens are good for practice, and for working out flourishes and roughs.

Inks and paint for writing

Paintings on ancient papyri show Egyptian scribes using a reed brush with a palette of two wells for black and red inks or paint. The black ink was made from collecting fine soot and mixing it with gum in a ratio of three to one. If the ink dried, water was added to dilute it. Red ink was made from mercuric sulphide which is found in cinnabar. It was ground to a powder then similarly mixed with gum so that it adhered to the papyrus.

Ink made from soot – carbon – was used in medieval manuscripts, too. The Latin for ink is *encaustum*, which suggests a more powerful mix than simply soot. Another black ink which bit into the surface of the vellum was made from tannin mixed with iron salts. Tannin is obtained from oak galls, which are the result of the gall wasp depositing its egg either on the soft bark of an oak twig or on a young bud. The reaction of the tree is to form a hard sphere, about 10 – 15 mm (0·5 in) in diameter. The adult wasp emerges from the gall, and its exit is indicated by a small hole. The best galls, though, are those which still contain the wasp as these have a higher tannin content. Oak galls can be collected from deciduous woods – preferably in the winter – as it is then easier to see the galls on bare wood.

Copperas, ferrous sulphate, are the iron salts which are usually mixed with the tannin. They can be obtained from specialist suppliers, a chemist or a pharmacy.

A recipe using oak galls was given in *The Pen's Transcendency* by Edward Cocker in 1672. 'Pour two gallons of rainwater into an earthen stand or vessel that is well leaded or glazed within; and infuse in it two pounds of gum Arabic, two pounds of Blew-galls (Blue) bruised, one pound of Copperas and two ounces of Roch (Rock) Allum: stir it every morning with a stick for ten days and then you may use it.' Francis Clement in *The Petie Schole* of 1587 wrote: 'Put into a quarte of water two ounces of right gumme Arabick, five ounces of galles, and three of copras. Let it stand covered in the warme sunne, and so it will the sooner prove good inke'. Some old recipes include stirring the ink with a fig stick. The gum from fig does have preservative properties, and as it is sticky may increase the ink's adhesion.

Oak gall ink is acidic but any quill affected by this could be easily recut. This ink, though, corroded metal nibs when they were introduced towards the middle of the nineteenth century. A less acidic ink was required, and aniline dyes proved to be the answer.

Scribes require a dense black ink, which stays on the writing surface and covers any guidelines, but is thin enough to pass through the pen. Some manufactured calligraphy inks fulfil this role, others are watery or thick and sticky. Even inks from the same manufacturer can differ from time to time. Choose an ink which is recommended by colleagues, which is dense

1 Collect 80 g (3 oz.) of oak galls, place them in a polythene bag, wrap this in old newspapers and crush them well with a hammer.

2 Place the crushed galls in a glass jar and cover them with rain water.

3 Leave the jar in the sun for two days.

4 Add 50 g (2 oz.) of copperas and the resulting pale brown solution will turn black.

5 To make sure that the ink thickens and adheres to the writing surface add 25 g (1·5 oz.) of ground gum Arabic to the liquid.

6 Leave again in the sun for a day then strain the resulting liquid through a nylon tea strainer.

If a sediment forms, strain again. The depth of colour increases on exposure to air.

in the bottle, but which, when the bottle is tilted, is not too thick – although thick ink can always be watered down. The consistency of calligraphy ink should be similar to thin, runny cream.

If manufactured calligraphy ink does not satisfy your demands, then you can produce your own from paint – gouache – or ink sticks.

Gouache is a paint available in tubes, similar to water colour but containing artificial barium sulphate which makes it opaque. It is available in a wide range of colours, and, if you have the choice, select artists', rather than designers', colours as these are usually more finely ground. Squeeze a little of the paint from the tube and wipe off any gum. Place about 1 cm (0·5 in) into a palette or white saucer. Add water drop by drop and stir with an old paint brush until the liquid is the consistency of thin, runny cream. Feed the paint into the pen with a brush as you would ink. After use, loosely cover any unused paint to protect it from dust and add more water if necessary when you use it again. Gouache can be mixed to produce any combination of colours, and is an economical form of ink. It also usually reacts better than ink on difficult papers.

Dried ink in the form of ink sticks is available from most Chinese goods suppliers, usually in black, although sometimes in packs of a limited range of colours. These coloured ink sticks are not always of good quality, although red, when it is sold separately, is often a wonderfully bright vermilion.

Ink stones should be used with ink sticks, and these can be purchased quite cheaply from the same suppliers. Ink stones, usually made of slate, have a slightly abrasive surface which aids the ink-making process. Pour a little water into the well of the ink stone, place the ink stick into the water and move it backwards and forwards using the whole area of the ink stone as you do so. Gradually the clear water will change to a pale grey solution and finally to a dense black. Use the ink at whatever density or thickness you wish, thinner perhaps for roughs or for special effects, thicker and blacker for final formal pieces. Ink made in this way does not keep well in liquid form. If you have made too much for your use, you can decant the excess into a small glass jar but it will separate within the week.

To repeat exactly the density of ink, count out a specific number of drops of water added and grind for exactly the same length of time when making new batches of ink.

Wash the ink stone out after use, using an old toothbrush to remove ink from the corners. Stale, dried ink will affect any new mix.

油煙墨

松煙墨

成油煙墨

It is difficult to obtain good-quality Chinese ink sticks outside China. These characters, often on the top of the ink stick, indicate the origin of the soot used to make the ink.
TOP: *Vegetable oil smoke – the best.*
MIDDLE: *Pine oil smoke – the next best.*
BOTTOM: *Synthetic oil smoke.*

Parchment, Vellum and Paper

A variety of materials served as writing surfaces in the ancient world – stone, pottery, wax, leather and papyrus being only some. All had various advantages but many disadvantages. Lengthy information was written on scrolls often made of papyrus, which, because of handling could only be used on one side. Lengths of the scroll had to be unrolled to find a particular reference. Papyrus, however, can be quite brittle, and it will not withstand a definite fold and constant opening and closing, as in a codex, without breaking.

Parchment, named after the city of Pergamum (now Bergama in Turkey), had been known and used, as was vellum, mainly for informal writing from the second century BC. It was, and is, prepared so that both sides of the skin could be used as a writing surface but, until the growth in popularity of the book or codex form, from the time of the Emperor Constantine (AD 280–337)

1 Select a piece of vellum which is about the same thickness all over to avoid undue cockling.

2 Sprinkle a little pounce or pumice powder on to the skin and gently rub all over with a scrap of vellum, a piece of cotton wool or even your fingers. Take care with this as too vigorous an action may cause the skin to crease or cockle.

Fold a large piece of scrap paper in half and then open it out. Position the vellum over this paper and gently tap the skin. The pounce powder will fall on to the paper; brush off any excess from the vellum. The powder can then be tipped into a screw topped jar for re-use.

*3 Use fine grade wet and dry, or abrasive paper which is about 400 grade to raise the nap. Fold a piece of this paper over a cork block and gently rub all over the vellum **only where you are to write**, until you can see the smooth surface of the skin become almost like fine velvet or suede. Take great care not to crease the vellum nor to rub down too much in one area so creating excess heat and cockling.*

*4 Grind a dozen or so lumps of yellow gum sandarac in a pestle and mortar until a fine pale yellow powder forms. Tip this on to a 10 cm (4 ins) square of finely woven cotton, such as an old hand-kerchief or piece of sheeting. Gather the sides up and tie with string. Dab the powdered gum sandarac over the vellum **only where you are to write**. Brush off any excess.*

(NB Some people are allergic to gum sandarac and it is also poisonous so you are advised to wear a mask and pro-tective gloves for this process.)

5 Your vellum is now ready for you to paint or rule lines for your lettering.

6 Any errors in painting can simply be washed off with clean water and a brush, and blotted with a piece of paper kitchen towel. Writing errors can be removed in the same way, or use a piece of fine abr-asive paper to rub over and erase your mistake. Then write in the correct letter or word, although it is wise to test the skin first, and add a little powdered gum sandarac over the erased area if necessary.

onwards its use was confined mainly to scrolls. From the middle of the fourth century AD books generally took the codex form which we recognise now; the *Codex Sinaiticus,* an example of an early high-quality codex, is now in the British Library (Add. MS 43725) and was written in Caesarea during that century.

Parchment and vellum

Both parchment and vellum are used as all-embracing terms. It is now usually accepted that parchment is sheep or goat skin and vellum calf skin. Both were used in medieval books, but only one is recommended for use today.

Sheep skin is greasy, and contains an insulating fatty layer between the hair side of the skin and the flesh side, which enables a sheep skin to be split into two separate pieces. Despite the parchmenter's efforts to remove the grease, parchment is a difficult skin to prepare effectively for writing. Significantly for scribes, it is also difficult to remove mistakes from the skin. Because of this, it was used for court records so that any alterations could be easily seen. Whole sections can be removed from vellum, however, without any detection, a quality which was used in *palimpsests* (where skins were cleaned and used again). Vellum can also be prepared so that the finest of hairlines are achieved, and is much the preferred writing surface.

Skins are prepared by being soaked first in vats of lime, and agitated from time to time; this cleans the skin, removing any remaining hair and dirt. Once out of the lime vats, the skins are stretched on wooden frames. Thongs are attached to wooden pegs in the frame which allows the skin to be stretched further while being treated. Small smooth pebbles (or more often nowadays, screwed-up balls of newspaper) are pushed into the skin from the back, and the thongs are wound round these. The parchmenter uses a half moon or lunar knife to scrape the skin, adding water, and bleach if necessary. The skin remains under tension and is kept damp. When it is smooth and of the required thickness the skin, remaining on its frame, is allowed to dry in a controlled atmosphere. Finally the skin is cut from the frame and rolled ready for use.

Vellum is available in different finishes. **Calfskin** manuscript vellum is the most suited for formal work as it is a creamy white and finished on both sides. **Classic** vellum has more of the character of the skin but is finished on one side only, as is **Book binder's** vellum. **Slunk** vellum is from newly born or aborted calves and is so fine that it is almost transparent. **Kelmscott** vellum is heavily prepared with chalk for printing and is unsuited to calligraphy but is a good surface for miniature painting.

Vellum should be stored flat ready for use. It helps if it is weighted down slightly, as damp or heat will encourage the skin to cockle. The weight of the heavy binding boards, clasping mechanism and the sewing of leaves into a codex help to keep the vellum steady in manuscript books.

Before you use vellum, it is best to treat it carefully for writing or painting. The grease must be removed with pounce or pumice powder and the nap gently raised so that there is a good tooth for your quill or pen. Cut a piece of vellum to the size you require from a whole skin.

If you are only using one side of vellum then choose the hair side as it will produce better letter-forms. There is a difference in look and feel between the hair and flesh sides. Look for the side which is whiter, feels smoother and has an almost waxy finish. Turn over the vellum and notice that the other side has more colour, and character to it; there may even be a few hair follicles still visible. This is the hair side and is the side to use.

<table><tr><td>

TO DETERMINE GRAIN DIRECTION IN PAPER

You can do one of four things:

1 Gently push over one side of a large sheet of paper in half one way and then the other. In one direction the paper will fold over, in the other direction the paper will resist and spring back, and only remain bent over if you hold it with your hand. The grain direction is parallel to the fold when the paper folds easily.

2 Dampen the corner of a piece of paper, about 5 cm (2 ins) along the edges at right angles. The paper will curl along the grain direction.

3 Tear a piece of paper – perhaps from a rough. Paper will tear easily along the grain direction, and will resist tearing across the grain direction.

4 Hold about 20 cm (8 ins) of paper along one edge between the fingers and thumbs of both hands. Bend the paper between your fingers and thumbs. Now repeat this with a piece of paper along the edge at right angles to this first edge. There will be more 'give' in the paper in one direction. This is the grain direction.

</td></tr></table>

A parchment-runner. This would be moved down a sheet of vellum or paper and the pinprick marks would indicate the line spacing.
From the Philip Poole Collection.

Paper

John Tate, who had a paper-making mill in Stevenage, Hertfordshire, was the first recorded paper maker in England; his name is included in a household book of Henry VII in 1498. Paper was made in Spain in 1150 and before that in Baghdad in 793, having spread slowly from its origins in China where it was made in the first century AD. The first papers manufactured in Europe were used for cheaper manuscripts and printed books and were made from rags. Its quality was not always suitable for use by scribes.

Paper is made from cellulose, nowadays often in the form of wood pulp. The fibres are broken down in vats of water, mixed with fillers, whiteners and size, allowed to fall on to a conveyor belt, and then gently squeezed between rollers to remove the water. Paper is finished in three ways. **Hot press** paper has been passed through heated rollers which give a smooth surface, suitable for writing. **Not**, or **cold press,** paper is passed through unheated rollers resulting in a surface which is less smooth, but interesting for scribes working on less formal pieces. **Rough** paper is not pressed at all.

Hand-made paper is made in a similar way with the same three finishes, however the paper fibres are scooped on to a wire mesh contained within a frame. This allows the fibres to settle at any angle, and hand-made paper thus has no **grain direction.** All manufactured paper has a grain direction of some sort, although mould made paper usually has only a little. Grain direction is the direction of the paper fibres and needs to be taken into account when making books, folding or tearing paper. The grain direction should be parallel with the fold of paper.

Paper is also manufactured in different **weights**, indicated by a number followed by gsm (grammes per square metre) or gm². The higher the number, the heavier the weight of paper. Choose a good-quality paper of a reasonable weight, at least 150 gsm for books or best pieces. Layout paper, about 45 gsm, or photocopying paper, about 80 gsm, is perfectly adequate for practice and roughs.

Other tools and equipment for scribes

Early scribes used simple tools and equipment as aids to their writing. They wrote at a sloping board so that the ink was controlled and it was more comfortable when writing for any length of time. Early boards were probably propped up on another piece of wood; later they became more sophisticated. You may choose to prop up a sturdy piece of wood on bricks, or buy an adjustable drawing board perhaps with a sliding rule. Whatever your choice, the angle of the board should be at about 45°, although this can be lowered if the ink is not flowing well, and raised to a steeper angle if the ink is flooding from your pen or quill.

It is not known whether sheets of prepared vellum or parchment were used to act as a cushion, giving a sympathetic writing surface, but this is now advisable especially with manufactured boards, which have a very resistant surface. Set your board up as shown on the next page. Left-handers may find it more comfortable to position their writing paper at an angle of about 25° – 30° to the horizontal.

Guidelines in early books were scored into the pages using a blunt point, giving an indentation on one side and a raised line the other. Later, from around the late twelfth century, a silver or lead point produced lines which

15

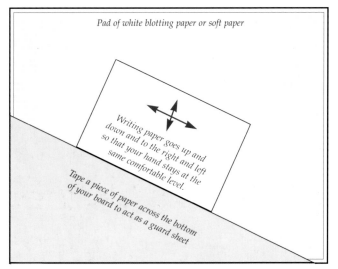
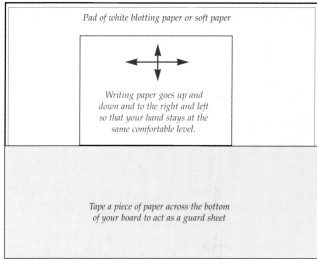

Pad of white blotting paper or soft paper

Writing paper goes up and down and to the right and left so that your hand stays at the same comfortable level.

Tape a piece of paper across the bottom of your board to act as a guard sheet

Pad of white blotting paper or soft paper

Writing paper goes up and down and to the right and left so that your hand stays at the same comfortable level.

Tape a piece of paper across the bottom of your board to act as a guard sheet

Set up your writing board to give a sympathetic surface for writing and so that your writing paper is protected from dirt. Experiment until you find the most comfortable height for your writing hand. Mark the board with a small pencil line. Tape the guard sheet 2 – 3 cm (1 in) below this point.

LEFT: *left-handers may find this arrangement more comfortable.* RIGHT: *board set up for right-handers or left-handers with a flexible wrist.*

were easier to see in poor light. Indeed our 'lead' pencils (which are made of graphite) indicate their history from the name. In some medieval books, from around 1300 onwards, fine lines in red and purple ink, as a sign of quality, were ruled and not erased. Most scribes prefer to erase their guidelines now, and the sharp point of a hard pencil, about 4H, gives a clean line which can be seen when you are writing and removed with a soft eraser when the ink has dried.

A tiny pinprick, often seen on the sides of pages in historic manuscripts, indicated where those guidelines should go. Today sets of dividers, with points set in the arms at one end with those arms joined together at the other can easily be 'walked' down the side of the page, so too could a parchment-runner or scrivener's wheel (*see* page 15). You can adjust most sets of ordinary, cheap compasses to make dividers as a quick and easy method of marking lines as these compasses which are sold with extra leads usually contain a spare point too. Simply replace the pencil lead with the point, resulting in a point at the end of each arm, and you have made a set of dividers. Move the arms so that the two points are the distance apart of your guidelines and the resulting pinprick marks down the page will show you where to draw your lines. These can be trimmed away with a knife and metal straight edge if you prefer them not to be visible.

Set-squares and T-squares have been used since earliest times to ensure that lines are straight and square and they are just as helpful to modern scribes in ruling straight lines for writing. We also have the additional benefits of drawing boards with parallel sliding rules and cheap 'rolling rulers' which, although not always accurate, do provide a quick and easy method of ruling lines. Always choose a set-square, T-square or ruler which is longer than you think you will need rather than shorter. When drawing lines it is literally twice the effort if your ruler is not long enough to stretch across the width of the writing area on your paper.

Analysing the Scripts

Patricia Lovett

Caroline minuscule.

English Caroline minuscule.

uiro quide

m pareret,

Italic.

sed iudi

uit om

Uncial with an angled pen.

Gothic Book Script.

Rather than learning alphabets by starting with the first in this book, begin with those which are more straightforward. The styles above are all good for beginners and improvers. Start with Caroline, English Caroline or Italic, and then progress to Uncials with an angled pen and Gothic Book Script.

Studying manuscripts from the British Library, and from other great historic collections, is an ideal way of recognising the characteristics of hands and noting how they were used, but treating them as absolute, perfect exemplars does have drawbacks. The letter you identify as an exemplar may not be a particularly good example; when the scribe was tired, the slant of the letters may have increased; a dull quill would have produced letters which were not sharp and crisp; and the alphabet in early books consisted of fewer letters than we use now. Given these and similar problems it is wise first to analyse the letters in the manuscript examples, and then adapt them for modern use. For this reason, an example of each hand, with an up-to-date interpretation, is shown with the individual sections of this book.

It is also worth noting at this point that the following chapters are essentially in historical order, which is not necessarily the best order in which to tackle the hands calligraphically. Some alphabets, such as Uncials with a flat pen, require much pen manipulation and this is not easy if you do not have good control of the nib and flow of ink. It is probably better to start with one of the alphabet styles shown on the left although not necessarily in that order. Others are more challenging and should be studied when you are familiar and comfortable with making letters.

Using a manuscript for analysis

One of the main principles of calligraphy is that the letters in one alphabet style are similar in height. The body of the letters, called the *x-height* (because it is the height of a minuscule letter **x**), is contained within a top and bottom horizontal line and the ascenders (parts of the letter which go up as in **b, d, f, h**) extend above the top horizontal line, and the descenders (parts of the letters which go down, as in **g, p, q, y**) extend below the lower horizontal guideline. Scribes in early manuscripts used guidelines, but rarely two parallel lines precisely encasing the x-height. Usually their guides were simply baselines. Measuring an exact x-height in any manuscript may depend on

17

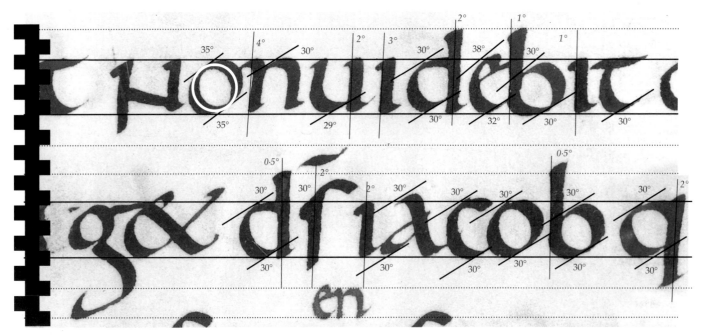

Analysing letters in the Ramsey Psalter to determine:

 a *x-height and heights of ascenders and descenders*
 b *pen nib angle*
 c *shape of the letter* **o**
 d *slant*
 e *stroke sequence*
 f *speed*
 g *serifs*

(NB. The letter **q** *at the end of the second line has been moved from two lines below to show the different heights of descenders. The letter* **g** *is almost two full nib widths longer than other descenders.)* BL, Harley MS 2904, f. 118.

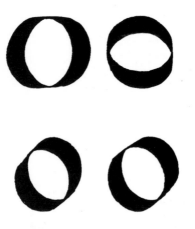

Letters **o** *made (clockwise from top left) with the pen nib held at: 0°, 90°, 30° and 45° to the horizontal. (Note the counters, or inside white spaces, on these letters.)*

the point where that measurement is being taken and it is worth taking more than one set.

To determine x-height, draw horizontal lines using a pencil and ruler across the tops and bottoms of the body heights of the letters. Now note the thickest parts of the letters such as on letters **o, c, d** and **e,** and select a pen nib which is the closest in width to this thickness. When you have a good match charge your nib with ink and, holding your pen so that the nib is at 90° to the horizontal guidelines, make a series of little steps which start from the lower guideline and just touch one another but do not overlap. Carry on until you have reached the top line for x-height – you may well go over this top line. Count up the number of complete and part pen widths; this is your x-height.

At the same time, you may wish to determine the heights of ascenders and descenders. Draw additional horizontal guidelines along the tops of the ascenders, and again along the bottoms of descenders. You may find that there are inconsistencies here, some letters always being longer or shorter – so take an average. Continue the little steps with your nib at 90° to the guidelines above and below the lines for x-height. Count these up. You may find again that there is a difference between lengths of ascenders and that of descenders. Your choice now is to be exactly true to the manuscript or make these heights the same. Most modern scribes choose the latter.

Another principle of calligraphy is that letters written with a broad-edged nib are made by holding the ***pen nib*** at a consistent ***angle*** for most strokes. This gives the letters their characteristic thicks and thins. The shape of the counter or inside of the letters changes as the nib angle changes; letters are fatter and chunkier when the nib is held at a low angle to the horizontal guidelines, and thinner when held at a higher angle to the horizontal guidelines.

Nib angle is not difficult to detect in a manuscript and is determined by drawing a series of lines with a pencil and ruler as a tangent across the narrowest parts of the letters, such as on letters **o, c, e, d.** This is shown in the manuscript above. The angle made by these lines against the horizontal guidelines can be measured using a protractor and an average taken.

The ***shape of the letter o*** is crucial to almost all alphabet styles – is it narrow and slanting, round and fat, or squashed to make a grapefruit shape? Other

letters, such as **c, d, e, g, p, q** take their form from the letter **o**, and still more are influenced by parts of that letter. The arch shapes of letters **b, d, m, n** for example are formed from part of that letter **o**. A narrow slanting letter **o** in Italic produces the characteristic springing arches for these letters in that hand.

The letters in most historic alphabet styles are written upright or with a gently forward *slant*. This can be measured by drawing a series of lines with a pencil and ruler parallel to the straight ascenders and descenders. The angle can then be measured using a protractor against a line drawn at 90° to the horizontal guidelines, as the angle of slant is taken in degrees from the perpendicular.

Pencils and ball point pens can be pushed around so that they write at any angle. This is not so with a broad edged nib which, if pushed upwards or to the left will resist the movement and usually spray ink. Letters are therefore often made with more than one stroke, the pen being lifted from the paper between strokes. This can sometimes be seen in enlargements of manuscripts where two separate strokes of the letter **o** may not meet exactly. In the following chapters, this analysis of letter construction – the *stroke sequence* – has been done for you and the order and direction of strokes are shown as numbered fine lines and arrows.

When starting a new alphabet it may seem natural to start at the first letter – **a** – and continue until through until the last – **z.** However, you will find that it is easier, and you will make progress more quickly, if you practise the letters in groups where the strokes used are similar. Not only has letter analysis been done, but so has the grouping of letters into *letter families*; this should ensure the quickest progress in learning a new alphabet style.

The number of pen lifts, letters joined together (ligatures) and a forward slant are all indicators of the *speed* at which the hand was written. Insular minuscule, for example, was written at a greater speed than Gothic Book Script, which has carefully constructed letters and many pen lifts. However, cursive, linked letters are different from those which join merely because they are written more closely together.

Some letters start with quite contrived *serifs,* which are the lead-in strokes or lines at the top and sometimes also at the bottom of letters, others are simply starting strokes of the pen. The way in which letters end should also be considered when copying or adapting. Present trends are towards simplification, but you may choose to use the more elaborately constructed serifs in your writing. Do remember, however, that dull quills produce neither good letters nor good serifs. A blobby start to a letter may be because of quill quality, not because of the scribe's intention.

The bases of letters such as **t, b** and **l**, construction of the letter **g**, the ampersand and possibilities for the construction of letters not used at the time can all be deduced from close study of the manuscripts shown in this book.

*The shape of the letter **o** determines the associated arch-shapes in many alphabets. This is shown here, from the top, in Uncials, Caroline, English Caroline, Gothic Book Script and Italic.*

Serifs change the look of ascenders. Top left are club serifs made with two strokes (or more likely one stroke if a flexible quill is used and pushed up), beak serifs, again with two strokes, simple hook serif, straight line serif, and a heavier weight serif made by a flatter nib angle.

Right: *The x-height and heights of ascenders and descenders, pen angle, form of the letter **o**, slant, and serifs determined by the analysis of the extract of the Ramsey Psalter on the previous page. BL, Harley MS 2904.*

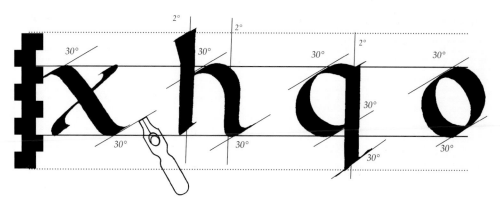

There is no such whetstone,
to sharpen a good wit and
encourage a will to learning,
as is praise.

Inter-letter spacing

There is narrow spacing between the letters which gives emphasis to the white spaces between the words. Legibility is not easy and the texture is uneven.

There is no such whetstone,
to sharpen a good wit and
encourage a will to learning,
as is praise.

The inter-letter spacing is about the same as the inter-stroke spacing. This gives an even texture and the legibility is good.

There is no such whetstone,
to sharpen a good wit and
encourage a will to learnin,
as is praise.

Wide inter-letter spacing gives an even texture, but legibility is difficult.

There is no such whetstone,
to sharpen a good wit and
encourage a will to learning,
as is praise.

Inter-word spacing

There is narrow spacing between the words which produces a very dense texture and makes legibility difficult.

There is no such whetstone,
to sharpen a good wit and
encourage a will to learning,
as is praise.

*The inter-word spacing is about the same as the width of a letter **o**. This gives an even texture and the legibility is good.*

There is no such whetstone,
to sharpen a good wit and
encourage a will to learning,
as is praise.

Wide inter-word spacing gives an uneven texture but good legibility. However, the eye tends to rest on single words rather than flowing along the line.

There is no such whetstone,
to sharpen a good wit and
encourage a will to learning,
as is praise.

Inter-linear spacing

Inter-linear spacing here is the x-height, four nib widths. Legibility is difficult, the texture is dense and there will be ascender and descender clashes.

There is no such whetstone
to sharpen a good wit and
encourage a will to learning
as is praise.

Inter-linear spacing is twice the x-height, eight nib widths. Legibility is good, the texture is even and there are no potential ascender and descender clashes.

There is no such whetstone,
to sharpen a good wit and

encourage a will to learning,

as is praise.

Inter-linear spacing is three times the x-height, twelve nib widths. Legibility is good, the texture is even and the appearance elegant.

Differences in inter-letter, inter-word and inter-linear spacing affect legibility, the texture of the alphabet style and how it looks on the page. Wider spacing in all cases does not necessarily produce a more legible text.

Spacing

Studies of the manuscripts will also reveal inter-stroke, inter-letter, inter-word and interlinear spacing, all of which affect the look of the page. However, care should be exercised in too literal an interpretation of this. Grander and more important books may have had wider spacing between lines, words and letters. Smaller more personal books may have been written with quite a tight and dense text on the page. Use these manuscript examples, and any others that you may see, to help you capture the spirit of the hand rather than that of only one specific manuscript, as this will lead to more successful outcomes in your interpretation of historic hands.

Capital Scripts

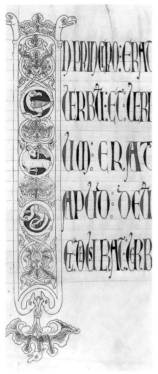

A classical author, from the Vergilius Romanus, Rome, fifth century. Bibl. Apost. Vaticana, MS Vat. Lat. 3867, f. 3v.

Gospelbook with Lombardic Capitals used as a display script. St Augustine's Canterbury, c. 1140–50. BL, Royal MS 1. B xi, f. 114v.

Capital letters are the oldest to have been used in the Roman or Latin alphabet, which is still used in the West. They evolved via Phoenician, Greek and Etruscan alphabets and were used by the Romans from the first century BC onwards. Square Capitals were probably the earliest, their angular form being governed by the chisel which worked them for monumental inscriptions (*scriptura monumentalis*). The crispness of letter-forms and the angular elegance of the head and feet of letter-strokes can be seen in the example illustrated from the Appian Way, one of the great 'motorways' of the Empire. Military masons ensured that fine examples of this imposing script were seen from Hadrian's Wall to Jerusalem and these long-lived relics of Rome's grandeur continued to influence subsequent heirs of Rome, such as the Anglo-Saxon settlers of Northumbria who carved the dedication stone of the church at Jarrow (dated 685) in Square Capitals. The famous Renaissance scholar-scribe, Bartolommeo Sanvito (1435–?1518), was commissioned much later to make antiquarian drawings of ancient Roman inscriptions and was inspired by them to produce his characteristic vari-coloured lines of elegant Humanistic Capitals. The examples seen on pages 26 and 114 are from the King's Virgil, (BL, King's MS 24), which was probably made at the end of the fifteenth century by Sanvito for a member of the Agneli family of Mantua, to judge by the number of lambs featured in its decoration. Another example of Sanvito's epigraphic Square Capitals and decorative elements inspired by antique monuments is the copy of Eusebius' *Chronicle* (BL, Royal MS 14. C. iii; *see* page 34) which he made for Bernado Bembo during the 1480s.

The effort required to write Square Capitals with a pen meant that they were seldom used for complete texts, although some rare examples of ostentatious early codices written in Square Capitals survive, notably a fourth-century Italian copy of Virgil's *Georgics* (the Codex Augusteus, Biblioteca Apostolica Vaticana, MS Vat. Lat. 3256). However, they retained their position at the top of the hierarchy of scripts and were frequently used in display scripts designed, with decorated initials, to mark important divisions in the text.

21

Top: *Epigraphic Roman Capitals from the Appian Way, Rome, Italy.*

Below: *Enlargements of the letter* **V, M** *and* **P** *showing their balanced proportions and careful construction.*

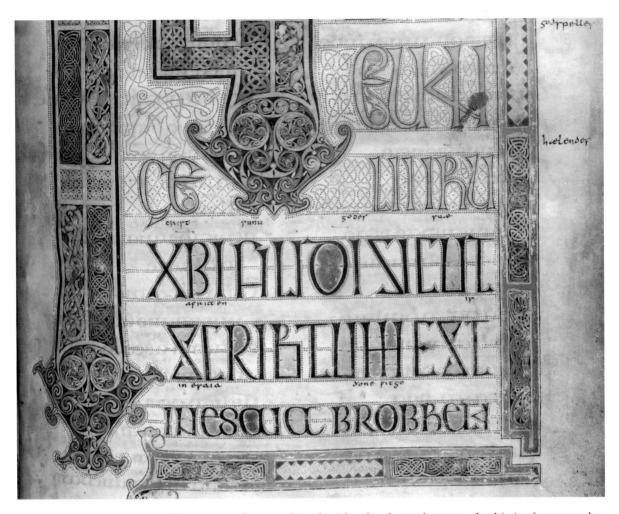

Display Capitals from the Lindisfarne Gospels. Lindisfarne, c. 698. BL, Cotton MS Nero D. iv, f. 95.

They were often combined with other letter-forms to do this in, for example, the 'Insular' display script of the Lindisfarne Gospels. Here, around 698, the artist-scribe devised exaggeratedly angular Capitals, perhaps influenced by carvings in wood, which are combined with forms inspired by the German runic alphabet such as an **M** consisting of a horizontal stroke crossed by three verticals. From the twelfth to fourteenth centuries they formed the basis of an elaborate, decorative display script known as Lombardic Capitals, acknowledging their early use in northern Italy. They can be seen here in a Romanesque Gospelbook – written at St Augustine's during the 1140s (BL, Royal MS 1. B. xi; *see* page 21). Its inhabited initial incorporates the *agnus dei* and is executed in a linear style with foliate decoration descended from the famous Anglo-Saxon 'Winchester style'. This is followed by lines of painted Lombardic Capitals, distinguished by their mixture of Capital, Uncial and minuscule forms embellished with curvaceous serifs. Such work represented the final flowering of the great period of the Canterbury scriptoria. Square Capitals were frequently revived in a purer form, sometimes as a conscious reference to imperial splendour. Such may well be the case with the imposing gilded capitals and monograms of the incipits (major openings) of the Benedictional of St Ethelwold (BL, Add. MS 49598), which was commissioned by Bishop Ethelwold of Winchester in the 970s–980s from one of his monastic scribes, Godeman. These would remind the informed viewer of the splendours of the Carolingian Empire, of Justinian's Ravenna and of papal and imperial Rome. The overt expenditure of resources was designed to leave the viewer

23

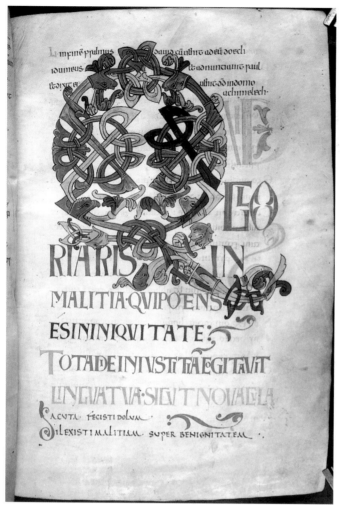

Roman Versals in the Bosworth Psalter.
Christ Church, Canterbury, late 10th century.
BL, Add. MS 37517, f.33.

Capitals written with a brush on the walls in Pompeii. The first indicates that this shop sold oil.

suitably impressed. As Godeman recalls in his scribal colophon, Bishop Ethelwold expressly instructed him to use plenty of gold and colours to embellish his personal book of blessings which he would be seen using on high days and holy days. Another example of the Anglo-Saxon use of capitals, in this case painted Roman Versals, letters drawn in outline, is to be seen in the incipits of the Bosworth Psalter (BL, Add. MS 37517), which was made in southern England, probably at Christ Church, Canterbury, in the late tenth century and which, it has been suggested, may have belonged to St Dunstan. The alternate lines of pink, blue and red capitals used in its display script represent more idiosyncratic local variants on capital forms, and feature some curious foliate protuberances and curvilinear serifs, but their cultural resonance remains ultimately reminiscent of ancient Roman inscriptions.

Display capitals were often produced with a brush and in order to adapt the angular capital forms to the pen (initially the reed pen or calamus and from the sixth century the quill or penna), Rustic Capitals probably emerged. These had more fluid lines, feet and serifs and permitted greater scribal spontaneity. The earliest example is a fragment of a poem on the Battle of Actium. The fragment was buried at Herculaneum in AD 79 by the lava and ashes of Mount Vesuvius. Ironically, these Rustic Capitals appealed to the stonemason who appropriated them for the less suitable chisel (Rustic Capital inscriptions being known as *scriptura actuaria*). Even Rustic Capitals were expensive for complete scrolls or books, and the publishers and bibliophiles of the Roman Empire reserved them for the most luxurious works. These would have included the Vergilius Vaticanus and the Vergilius Romanus – illustrated copies of works by Virgil penned by professional scribes probably for senatorial patrons during the fourth to fifth centuries. The Vergilius Romanus (Biblioteca Apostolica Vaticana, MS Vat. Lat. 3867; *see* page 30) was probably made in Rome during the second half of the fifth century and is one of several impressive early codices.

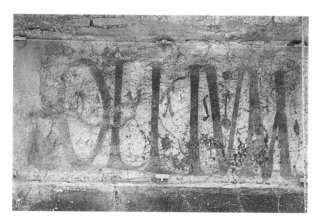

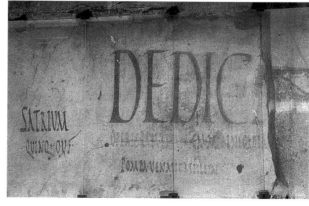

Rustics added at the beginning of the Vespasian Psalter probably after it was written at Canterbury, **c. 730.**
BL, Cotton MS Vespasian A. i., f. 3.

TSICUBI QVIS FEROACRABIDOFURORE APIETVR SIFORTE
DIXERIMCARMINIBVSINCANTATVS CONTINUOOMNISR
ABSCEDIT PSALMVSTRANQVILLITASANIMARVMEST SI
PERTURBATIONESVELFLUCTVSCOGITATIONVMCOHIBENS
LVXVMREPELLENS SOBRIETATEMSVGGERENS AMICITIASCO
INCONCORDIAMDISCREPANTES RECONCILIANSINIMICOS
IMICVMDVCATEVM CVMQVOVNAM ADDNI PSALMIEMIS
EXQVOINTELLEGITVR QVIAETQVODBONORVMOMNIVM
TATEM PSALMVSINSTAVRAT CONIVNCTIONEMQVANDAM
VOCISEFFICIENS ETDIVERSVMPOPVLVMVNIVSCHORI PE
MANS PSALMVSDAEMONESFVGAT ANGELOSINADIVTO
SCVTVMINNOCTVRNISTERRORIBVS DIVRNORVMREQVIES
TVTE LAPVERIS IVVENIBVSORNAMENTVM SOLAMENSE
APTISSIMVSDECOR DISSERTAHABITAREFACITORBIS SOI
INCIPIENTIBVSPRIMVMEFFICITVRELEMENTVM TOTIV
OSALMVSSOLLEMNITATESDECORAT PSALMVSTRISTITI
OMESTMOLITVR PSALMVSETIAMEXCORDELAPIDEOLA
PSALMVSANGELORVMOPVS EXERCITIVMCAELESTIVM
OVEREADMIRANDI MAGISTRISAPIENSINSTITVTVM U

When the codex, or book, 'came out of the closet' along with Christianity following the edicts of toleration of the fourth century AD, it became a vehicle for luxurious scripts and programmes of illustration (rather than decoration, for the treatment of text was still very restrained). Although such illustrated works had been eschewed earlier in Classical Antiquity as betokening a somewhat naïve taste, the sensibilities of the new Christian elite knew no such coyness, and lavish copies of the biblical texts were produced, such as the Cotton Genesis. This taste extended to the classics, the works of Virgil being an example. The Vergilius Romanus would have been an expensive work to commission and similarities of some of its illustrations to the ivory diptychs produced for consuls to commemorate their term of office may well point to similarly high-ranking patronage. Its script is attenuated and elegant, with several new calligraphic conceits incorporated, such as the extended head-stroke of **F** and the sensuous low-slung **L**. It should be noted that the medial points to separate words were added later. At this period texts were still written in *scriptura continua*, that is continuous script with no word division. From the sixth century onwards Irish scribes who were pre-occupied with the grammar and articulation of what was essentially a foreign language – Latin – were to address these issues and would introduce word

Capitals by Bartolommeo Sanvito. The King's Virgil. Commissioned from Sanvito by a member of the Agneli family of Mantua at the end of the fifteenth century.
BL, King's MS 24, f. 131v.

separation and a system of punctuating by means of a rising series of points (the more points, the greater the value of the pause). This development was also assisted by Bede and Isidore of Seville who advocated the transition to silent reading, rather than the reading out loud of the classical orator, to foster comprehension and meditation in a monastic context.

During the early Middle Ages particularly important monastic commissions sometimes also employed Rustic Capitals as an expression of *romanitas*. An example is shown here of prefatory matter written in a distinctive form of Rustics, added to the Vespasian Psalter (*see* page 25,) soon after it was produced in Canterbury around 730. Perhaps the most famous medieval example of the use of Rustics as a text hand, however, is the highly influential Utrecht Psalter (now in the University Library in Utrecht) which was copied from an

Roman Capitals

Letter height:
7 nib widths

Nib angle: 30°,
with some
changes for cer-
tain strokes

Letter O form:
Round

Slant: Upright

Stroke sequence:
As shown on the
exemplar letters

Speed: Slow

Serifs: As chosen.

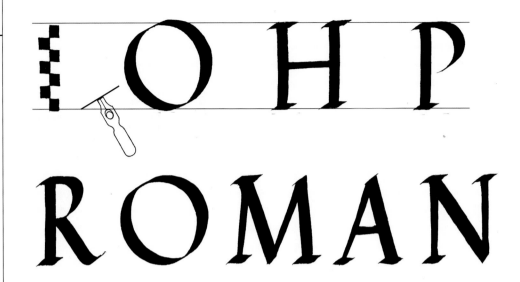

early Christian exemplar in the Carolingian diocese of Reims around 830 (*see* page 67, Caroline Minuscule) and which inspired numerous later versions which did not, however, emulate its labour-intensive Rustic Capital script. Later, Anglo-Saxon and Norman scribes were particularly partial to them and they also had a life during the Middle Ages and Renaissance for display scripts and headings.

Analysing the Script – *Roman Capitals*

Roman Capitals are the longest lasting style of lettering to retain their form and still be recognised and used today. Their classic proportions mean that they are as appropriate when used in monumental carving to celebrate the opening of a building by a famous dignatory, as they are when used on the disposable plastic carrier bag of a high street store.

The *x-height* is usually taken at 7 nib widths, and, being monumental capitals, there are no ascenders or descenders. Also, being a capital alphabet without ascenders or descenders to get in the way, the space between the lines can be so close that the letters can almost touch, or there can be much more space to give an elegant and graceful feel to the piece.

The *pen* is held at an *angle* of 30° to achieve almost all these lettershapes. On a few strokes, though, the pen angle is steepened or flattened for specific results. The pen angle for the first and third strokes of the letter **N** and the

Below right:
*Letters which require partic-
ularly careful construction.*
*The pen is held at 60° rather than
30° for the first and last strokes of
the letter* **N,** *and for the first stroke
of the letter* **M.** *This gives the let-
ter more visual interest. That same
letter* **M** *is not a wide letter. It is
the width of the letter* **V** *with two
supporting strokes. The letter* **W**
*is written as two slightly narrow-
er* **Vs***.*

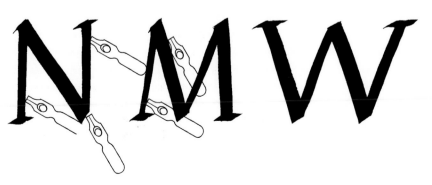

27

first stroke of the letter **M** are written with a steeper pen nib. This means that there is greater visual variety in the letter **N**, as a nib held at about 30° for all three strokes would result in a very dull letter (try it and see). Similarly for the letter **M**. For a **Z**, though, the pen is held at a flatter angle for the middle diagonal stroke. If the pen was not flattened then that stroke would be very thin and weak, producing a rather pathetic letter.

The *shape of the letter O* is round, with an oval white space, or counter, contained within the strokes for the round letters. It is quite difficult to produce a perfect round letter every time, and this is one of the letters which may take some time to perfect.

The *slant* of letters is a consistent 0° from the vertical, upright, with very little variation in the example shown. Scribes will appreciate how challenging it is to maintain that consistent perpendicular nature to the uprights with a large x-height of 7 nib widths.

The hand is written with care and at quite a slow *speed*, the letters being formed from a number of pen lifts. The *stroke sequence* is shown on the exemplar letters.

Serifs can be many and various. Traditionally they would have been slab serifs, with the nib held at the same angle of 30°. However, all the serifs shown on page 19 can be used with Roman Capitals. A casual hook serif gives the hand a quite different feel to downstrokes constructed with a beak serif. Whichever one you choose, make sure that there is a similar pattern to all the letters when you write them.

Because they can be combined with so many of the other alphabet styles, and because Roman Capitals give the pattern for other capital letters, it is worth looking closely at the family groups in terms of the widths of letters.

The letter **O** is the key. This outside of this letter, as a circle, can be encased within a square. That square gives the guidelines for width to all other letters. The letter **Q** obviously takes its shape from this key letter, and letters **C, G** and **D** use parts of that key letter.

Letters which are symmetrical are as wide as three-quarters of the square encasing that round **O**. Symmetrical letters are **A, H, N, T, U, V, X, Y** and **Z**.

The letters **B, E, F, J, K, L, P, R,** and **S** are asymmetrical and are as wide as half of that square.

The remaining letters are the odds. **I** is simply a straight stroke. The letter **M** contains the letter **V** at its centre, with two slightly splaying supporting side strokes. These should be quite tight into the letter – too wide and the letter **M** looks as if it is about to slide apart, too close together and the letter

*Below: Roman Capitals in their family groups according to width. The round letter **O** can be encased within a square. This gives an indication of the widths of the letters **Q, C, D** and **G**.*

*Letters which are symmetrical – **A, H, N, T, U, V, X, Y** and **Z** – are as wide as three-quarters of that square.*

*Asymmetrical letters – **B, E, F, J, K, L, P, R** and **S** – are half that square's width.*

*The odd letters are **I, M** and **W**.*

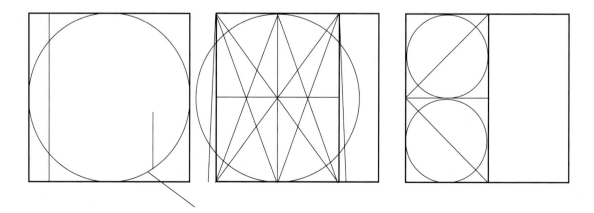

Letters based on a round letter O

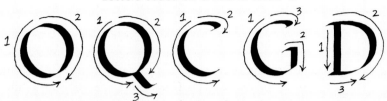

Asymmetrical letters which are three-quarters as wide as the round letter O

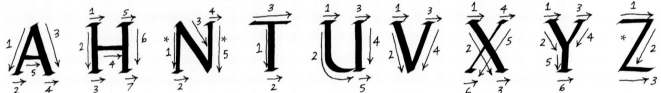

*Steepen the nib to 60° for the first and third strokes of the letter **N**, and the first stroke of the letter **M**. Turn the nib to 10° for the diagonal stroke of the letter **Z**.*

Symmetrical letters which are half as wide as the round letter O

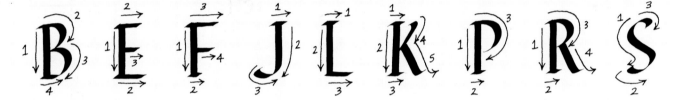

Letters with varying widths

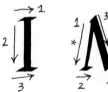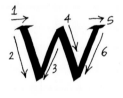

Ampersand

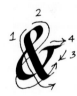

Punctuation

Numerals

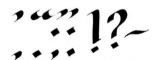

ABCDEFGHIJKLMNOPQRSTUVWXYZ

Writing Roman Capitals

29

INFELIXSVATECTASVPERVOLITAVERITALIS
OMNIAQ:PHOEBOQVONDAMMEDITANTEBEATVS
AVDIITEVROTASIVSSITQVEDISCERELAVROS
ILLECANITPULSAEREFERVNTADSIDERAVALLES·
COGEREDONECOVSSTABVLISNVMERVMQVEREFERRI
IVSSISSETINVITOPROCESSITVESPEROLYMPO·

 MELIBOEVS CORYDON THYRSIS

FORTESUB·ARGUTACONSEDERATILICEDAPHNIS
CONPVLERANTQ:GREGESCORYDUNETTHYRSISINVNVM
THYRSISQVESCORYDONDISTENTASIACTECAPELLAS
AMBOFLORENTESAETATIBVSARCADESAMBO
ETCANTAREPARESETRESPONDEREPARATI
HICMIHIDVMTENERASDEFENDOAFRIGOREMYRTOS
VIRGREGISIPSEPERDEERRAVERATATQ:EGODAPHNIM
ASPICIOILLEVBIMECONTRAVIDETOCIVSINQVIT·
HVCADESOMELIBOEECAPERTIBISALVVSETHAEDI
ETSIQVITCESSAREPOTESREQVIESCESVBVMBRA
HVCIPSIPOTVMVENTPERPRATAIVVENCI·
HICVIRIDISTENERAPRAETEXITHARVNDINERIPAS
AILNCVSEQ:SACRARESONANTEXAMINAQVERCV
QVITFACEREMNEQ:EGOALCIPPENNECPHYLLIDAHABEBA
DEPVLSOSALACTEDOMIQVECLAVDERETAGNOS·
ETCERTAMENERATCORYDONCVMTHYRSIDEMAGNVM·

Rustic Capitals in the Vergilius Romanus. Rome, second half of the fifth century.
Bibl. Apost. Vaticana, MS Vat. Lat. 3867, f.22.

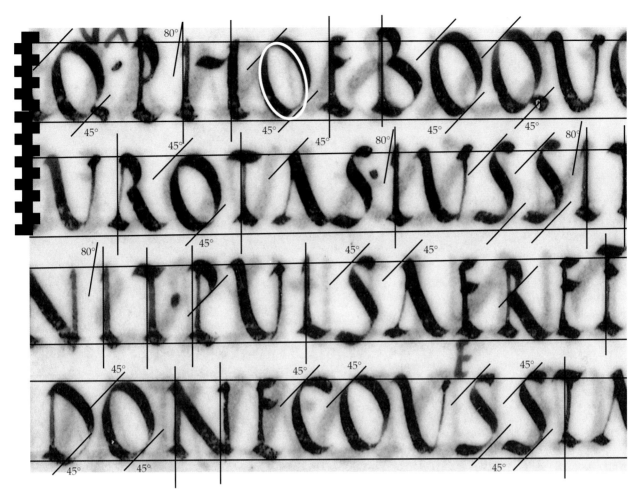

Enlargement of Rustic Capitals in the Vergilius Romanus. Rome, second half of the fifth century.

The angle of slant is so consistent that 0° has not been shown. Pen nib angle is shown as degrees from the horizontal.
Bibl. Apost. Vaticana, MS Vat. Lat. 3867, f.22.

looks mean and pinched. The letter **W** is a problem – the Romans very sensibly had nothing to do with it! Earlier in this century scribes would write it as two **V**s with the middle strokes crossing over, but this drew attention to its awkwardness. It is best written as two very slightly narrower **V**s, but not so narrow that they break the visual pattern of the hand.

Of course, there are always exceptions to the rule of related widths. The tail of the letter **R**, for example, usually pushes out beyond the restriction of that half-square. The letter **A,** too, is usually just a little wider than the three-quarters of a square width. Look at as many examples of Roman Capitals as you can to increase your knowledge of well-proportioned letters.

Analysing the Script – *Rustics*

There is a strong diagonal feel about Rustics despite the upright nature to the letters. This diagonal stress is due to the pen angle as the thickest strokes are those which are sloping from top left to bottom right. Delicate light uprights, with the nib held at such a steep angle that it is almost vertical, are not strong enough to act as a counter to these heavier diagonal strokes.

The pen *nib angle* for this alphabet style varies between these heavy diagonals and the lightweight uprights. The upright strokes are written with the pen held at 80° with a slight thickening of the stroke towards the base. It is likely that this stroke was made by increased pressure on a flexible quill. Holding a relatively inflexible metal nib at this steep angle and trying to exert pressure is very difficult. To achieve this shape either

31

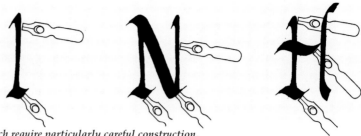

Letters which require particularly careful construction.

*Uprights, such as the letter **I** are made with the nib held at 80° and there is a slight thickening towards the base of the downstroke. This is made by moving the pen to the left at the end of the downstroke, lifting the pen from the paper and making a slight stroke to the right. Alternatively, you can use the left-hand corner of the nib to make this shape. It can be a little challenging to maintain this angle and a straight perpendicular line with a metal nib, but practice will achieve success. The letter **N,** similar to Roman Capitals, has narrow first and third strokes. It is also a wide letter, in contrast to others in this alphabet style. Write the thick diagonal stroke at 45° first to gain the width. Then construct the narrow uprights, with the nib held at an angle of 80° for both. Finally write the serif at the base of the first upright, with the nib turned once more to 45°. The letter **H** is also a wide letter. This is constructed by writing an **I** first, with the pen held at 80°. Turn the nib to 45° for the base serif and again for the cross bar which may or may not touch the second upright. Although not clear from the letter shown on the top line of the enlargement on the previous page, the second upright often starts with a flourish to the right. Make that downstroke curve in at the top from the right, with the pen again at 80° and finally add that serif stretching to the right at the top of the second upright.*

Rustics

Letter height:
7 nib widths

Nib angle: 80°,
for the upright
strokes, 45° for
the diagonals
and curves.

Letter O form:
Narrow com-
pressed oval

Slant: Upright

Stroke sequence:
As shown on the
exemplar letters

Speed: Slow

Serifs: Hook serifs
and slightly curved
slab serifs to base
and tops of some
letters.

move the pen slightly to the left at the base of the downward stroke, and then add a small stroke to the right, or use the left-hand corner of your nib to slightly increase the width of that part of the stroke. For this, press your nib down within the base serif after you have written it to increase the ink flow and then pull some of that wet ink into the upright stroke with the left-hand corner of the nib to construct the slight thickening at the base of the downstroke. It is those strong diagonal strokes which are made so bold in contrast to the light uprights by holding the pen nib at an angle 45°.

The *x-height* is seven nib widths, although some letters are slightly taller such as the letter **B** on the top line and the letter **F** towards the end of line 3, on the enlargement on page 31. This increased height for the letter **F** distinguishes between it and the letter **E** – otherwise both have a similar construction.

An angle of 45° gives the distinctive backward slanting counter (white space) to the letter O, which is a narrow, compressed shape. In fact the whole hand is most economical in its use of space. The *compressed letter O* gives the

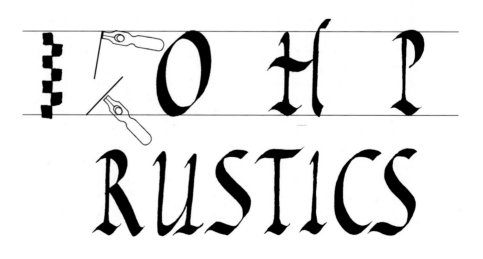

Letters which start with a downstroke

Note pen nib angles:
Narrow uprights – pen angle 80°
Diagonals, curves and most serifs
– pen angle 45°

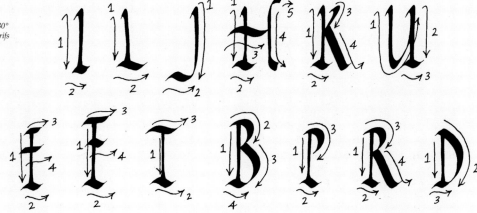

Diagonal letters

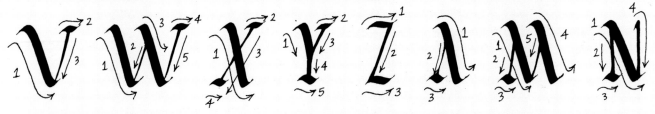

Letters based on the letter O

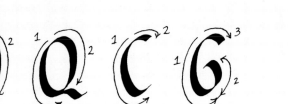

The letter S Ampersand

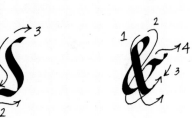

Punctuation

,.:;!?-

Numerals

1234567890

ABCDEFFGHIJKLMNOPQRSTUVWXYZ

Writing Rustics

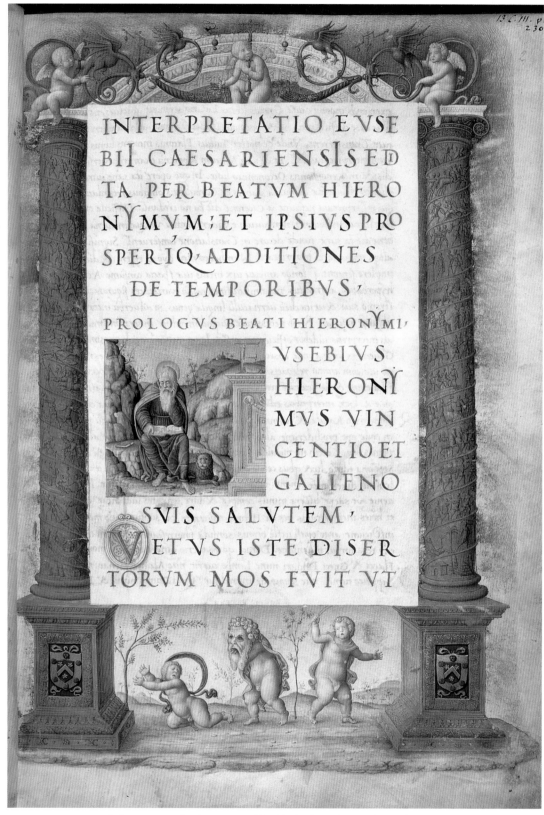

St Jerome as a scribe, from a copy of Eusebius' Chronicle *copied in Padua or Rome by Bartolommeo Sanvito, c. 1480–90, and featuring his distinctive Renaissance version of epigraphic Roman Square Capitals.*
BL, Royal MS 14. C. iii, f. 2.

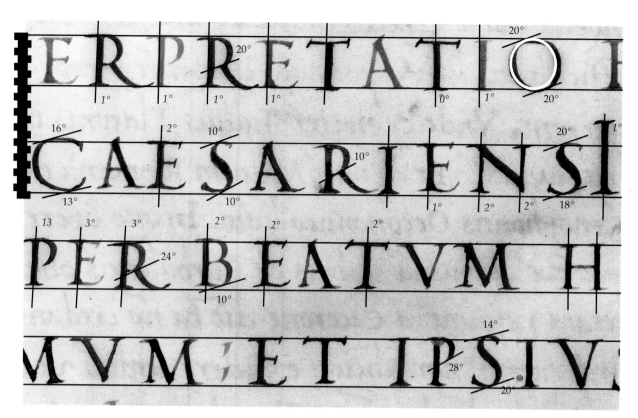

Enlargement of Renaissance Capitals written by Bartolommeo Sanvito.
Angle of slant is measured against the vertical. Pen nib angle is measured against the horizontal.
BL, Royal MS 14. C. iii, f. 2.

pattern for related letters such as **U/V, C, G, D** and even **A, N** and **B.**

The *slant* of the letters is almost consistently upright, with a careful and precise stroke sequence which is shown on the exemplar letters.

The serifs and the number of pen lifts do not suggest a hand written quickly; this is a gracious hand written at a slow *speed* to make an impression on the page.

Serifs are either a simple hook serif as on letters **I** and **L**, or a strong slab serif, made with the pen held at 45° on the bases of many other strokes – see letters **P, E, F, T, A, N, M** on the enlargement.

Analysing the Script – *Renaissance Capitals*

Bartolommeo Sanvito had a gift for making letters live! His wonderfully idiosyncratic adaptation of Roman Capitals is so versatile and modern that they work as well on their own as they do with many other minuscule lettering styles. It is your choice whether you decide to adhere firmly to the historical example or to update it and make the hand yours rather than Sanvito's.

As with most other capital alphabet styles, the *x-height* is about seven nib widths, although his letters do dance around the lines a little. There are no ascenders or descenders, but there are again letters which extend above the lines for x-height, as on the letter **I** at the end of the second line.

The pen *nib* is held at a low *angle* of about 20° to the horizontal, with some changes in angle for certain letters, similar to Roman Capitals.

Bartolommeo Sanvito wrote his letter **O** as a slightly squashed round, rather like a grapefruit, and this *shape of the letter O*, an extended letter, gives the pattern for the letters **C, G, Q** and **D.** The wide spacing of letters also allows for the extension of some strokes beyond what would be their normal width. The last stroke on the letter **R** for example, is particularly

35

Letters which require particularly careful construction.

*As with other capital alphabets, the first and last strokes on the letter **N** are narrower. You may find it easier to make the wider diagonal stroke first. Then turn the nib to an angle of 60° for the narrow uprights. Lastly make the serifs with the nib held again at 20°. Fill in any gaps with the left-hand corner of the nib. The letter **M** requires a number of pen nib angle changes to achieve a similar look to Sanvito's Renaissance Capitals. You may find it easier to construct the central **V**-shape first with the nib held at an angle of 20° for the first stroke, and 40° for the second stroke from the right down to the left. Turn your nib to 60° for the first narrow upright, and then to 20° again for the second upright, which is heavier. Lastly the serifs can be written with the nib held at 20°. You will have to use the left-hand corner of the nib to fill in gaps between uprights and serifs as before. This letter **R** is one of the most beautiful letters of all the alphabets. The downstroke and serifs are made first with the nib at angles of 20° and 2°. With the nib at 40° start the curved stroke and, as you bring it round, gradually flatten the angle to 20°, pressing on the left-hand corner of the nib as you approach the upright. The wonderfully swinging tail has almost a flourished feel to it and is made with the nib at 20° again.*

exuberant, and the letter **N** is wider than would be expected – much wider than the letter **H.** Compare these letters towards the end of lines 2 and 3.

There is a very slight *slant* to this hand, which perhaps adds to its gracious nature, and letters are written at an angle of about 2° to the vertical.

The *stroke sequence* is similar to Roman Capitals and is shown on the exemplar letters.

The *speed* at which the letters are written is slow, indicated by the careful construction of the serifs and the number of pen lifts. Those *serifs* are slab serifs with a degree of pen manipulation at the bases of letters **I, T, A P** and **R**, for example, to fill in the gap between the serif and upright.

Renaissance Capitals
Letter height: 7 nib widths
Nib angle: 20°, with some changes for certain strokes
Letter O form: Round
Slant: Upright
Stroke sequence: As shown on the exemplar letters
Speed: Slow
Serifs: As chosen.

Letters based on the letter O

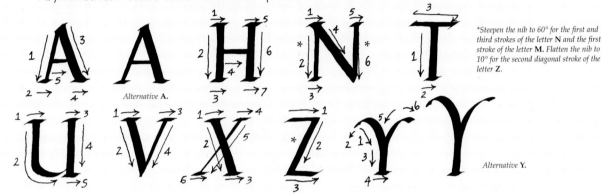

Asymmetrical letters which are three-quarters as wide as the letter O

*Steepen the nib to 60° for the first and third strokes of the letter **N** and the first stroke of the letter **M**. Flatten the nib to 10° for the second diagonal stroke of the letter **Z**.*

*Alternative **A**.*

*Alternative **Y**.*

Symmetrical letters which are half as wide as the round letter O

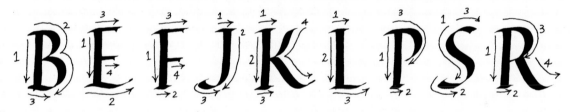

Letters with varying widths

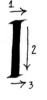
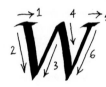
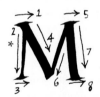

*Alternative **M**.*

Ampersand

Punctuation

Numerals

,, ,, '' '' : . . :!? 1234567890

ABCDEFGHIJKLMNOPQRSTUVWXYZ

Writing Renaissance Capitals

TO EVERYTHING THERE IS A SEASON,
AND A TIME TO EVERY PURPOSE
UNDER THE HEAVEN:

A TIME TO BE BORN, AND A TIME TO DIE;
A TIME TO PLANT,
AND A TIME TO PLUCK UP THAT WHICH IS PLANTED;
A TIME TO KILL, AND A TIME TO HEAL;
A TIME TO BREAK DOWN,
AND A TIME TO BUILD UP;

A TIME TO WEEP, AND A TIME TO LAUGH;
A TIME TO MOURN, AND A TIME TO DANCE;
A TIME TO CAST AWAY STONES, AND A TIME TO GATHER STONES TOGETHER;
A TIME TO EMBRACE, AND A TIME TO REFRAIN FROM EMBRACING;
A TIME TO GET, AND A TIME TO LOSE;

A TIME TO KEEP,
AND A TIME TO CAST AWAY;
A TIME TO REND, AND A TIME TO SEW;
A TIME TO KEEP SILENCE,
AND A TIME TO SPEAK,
A TIME TO LOVE, AND A TIME TO HATE;
A TIME OF WAR, AND A TIME OF PEACE.

Roman Capitals, Rustics and Renaissance Capitals are alphabet styles which have hardly changed over the years. We are familiar with the letters on Roman inscriptions, even if we cannot read the Latin. These letter-forms make a 'time-line' for us, and on this piece which incorporates all three alphabet styles, a 'time-line' forms the spine of the artwork. The quotation from Ecclesiastes, chapter 3, verses 1 – 8, appropriately fits the time theme .

Uncial

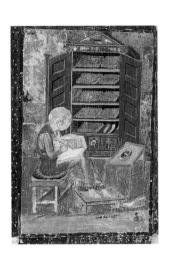

Ezra the scribe, adapted from a portrait of Cassiodorus. The Codex Amiatinus. Monkwearmouth/Jarrow, before 716.
Florence, Biblioteca Medicea-Laurenziana, MS Amiatino 1, f. V.

Uncial is the most formal book script to have enjoyed any major degree of use. Its rounded forms, which evolved during the second to fourth centuries AD, were suited to the action of the pen and represented a fusion of capital letter-forms and rapidly written variants with fewer strokes, which had become a script in themselves – Old Roman Cursive. The term 'uncial' is attributed, apocryphally, to St Jerome who is said to have criticised this de luxe script for being so ostentatious that it could appear to be an 'inch high' (*uncia* is the Latin for 'inch').

Uncial was commissioned of professional scribes by the publishers of the later Roman Empire and was used for sacred texts by the bishops and clerics who filled the vacuum left by the civil service at its demise, from the fifth century onwards. Its most influential patron was Pope Gregory the Great, instigator of missionary work amongst the 'barbarian' heirs to Roman rule in northern Europe. Around the year 600 Gregory encouraged the clerical scribes of Rome to pen elegant uncial copies of Scripture and of works by the Church Fathers (including Gregory's own influential compositions). These were designed to equip the expanding Church and to enhance the authority of this religion of the Word through the beauty and imposing character of its books. The symbols of faith, the Cross and the fish, began to adorn major letters and therein the process of integrating text and image through the decorated initial had its genesis, embodying Gregory's tenet that in images 'the illiterate read'. This pronouncement was a major step in determining the future of the book arts in the West. Idolatry was a significant preoccupation. The Islamic response was to espouse sacred calligraphy and to prohibit figural representations in sacred contexts. Byzantium was to be plunged into a lengthy period of iconoclasm during which images were actively destroyed, as they were around a millennium later during the English Civil War. In the West, Gregory's approval of the didactic use of images and decoration set the tone (although the question was sometimes reopened, especially in the Carolingian orbit). This allowed the 'barbarian' peoples of northern Europe to lavish their strong sense of ornament and style, with all its accompanying

39

Merovingian Uncials.
Origen, Homilies. France
(Corbie?), 7th century.
BL, Burney MS 340, f.24.

connotations of power and prestige, on to the new medium of the book. Only from such a heady brew of 'barbaric' and Mediterranean influences could manuscripts as stunning and innovative as the Book of Durrow, the Lindisfarne Gospels and the Book of Kells have been distilled. The direct influence of the cautiously decorated uncial books produced in Gregory's Rome can be detected in the already more ambitious initials of the earliest Insular manuscripts to survive from Britain and Ireland, such as the Cathach (or 'battler') of Columcille (Dublin, Royal Irish Academy). This is now thought to date to around 630, but was for centuries thought to be the Psalter that St Columba plagiarised, earning the famous legal judgement of 'to every cow its calf and to every book its copy' – the first statement of copyright. The conflict which ensued led Columba to leave his beloved Ireland in voluntary exile for Christ (*peregrinatio*) and to establish a monastic family (*paruchia*) which was to comprise such important foundations as Iona and Lindisfarne. Book production remained a core function of all such centres. Indeed, the Cathach became one of the major relics of the cult of St Columba and takes its name from the fact that it was carried before them into battle by its hereditary keepers. The talismanic power of the book is another important feature of the early Middle Ages during which it symbolised the Christian doctrines it so often contained.

Uncial continued in use in the cathedral cities and monasteries of early medieval Italy and Merovingian Gaul, often developing regional variant letter-forms, such as the Merovingian hooked **t** which can be so pronounced that it resembles an **a**. In a world torn by invasion and bloody power-struggles and with royal role models as murderers, even of family and friends, the ecclesiastical scriptorium would seem to have offered a haven of safety and tranquillity. This picture may be a naïve one, given that such religious centres were often hotbeds of much intrigue and mayhem, housing as they did many a nobleman and woman with political 'form'.

Across the Channel, in England, Rome and its Church exercised a greater hold on the imagination of the newly converted Anglo-Saxon peoples. Centres such as Canterbury, home of St Augustine's missionary endeavours from

ETINTERFECERUNTRECEM

INDOMOSUA

PERCUSSIT AUTEM POPUL

OMNESQUICONIURAUEI

CONTRA REGEM AMON

ETCONSTITUERUNT SIBIRE

Fragment from one of the
Ceolfrith Bibles.
Monkwearmouth/Jarrow, before
716.
BL, Add. MS 45025 f. 11v.

597, and the twin monasteries of Monkwearmouth and Jarrow, (founded by the eminent noble romanophile, Benedict Biscop, in the late seventh century) became focal points of *romanitas*. This was reflected in the regulated discipline of communal monastic life, influenced by the rules of life advocated by St Benedict and Cassiodorus, in which study and work figured, including the work of the scriptorium (for those so gifted). By 700 a whole hierarchy of scripts had been developed in the service of the British and Irish Church and its aristocratic sponsors. The English use of Uncial, never encountered in Ireland, was an informed one. The models favoured in such romanising centres for the meticulous reconstruction of this most Roman of scripts were those associated with Gregory and the papacy, rather than those of their Merovingian neighbours.

The scribes of Christ Church and St Augustine's Canterbury and of Monkwearmouth and Jarrow, who produced works such as the Vespasian Psalter, the Stonyhurst Gospel and the great Ceolfrith Bibles, would have taken pains to acknowledge and remain faithful to their stylistic sources. This did not inhibit their own calligraphic flair and inventiveness, as the first appearance of the 'historiated' (story-telling) initial in medieval art in the Vespasian Psalter, made in Canterbury around 730, shows. Here the attempts of western scribes and artists to link image and text in mutual validation reached new heights by actually turning the letter into a vehicle for the image. This was to remain an important feature of medieval manuscripts. The Vespasian Psalter continued to be an influential work in Canterbury. During the second quarter of the ninth century the earliest surviving translation of the Psalms into English was added between its lines in a pointed Insular minuscule script. It is probably one of the treasured books which the fourteenth-century commentator, Thomas of Elmham, describes as having been kept on display on the high altar of St Augustine's Abbey. It takes its name from its place in the library of its seventeenth-century owner, Sir Robert Cotton, who placed busts of the emperors over his bookcases. The Vespasian Psalter (BL, Cotton MS

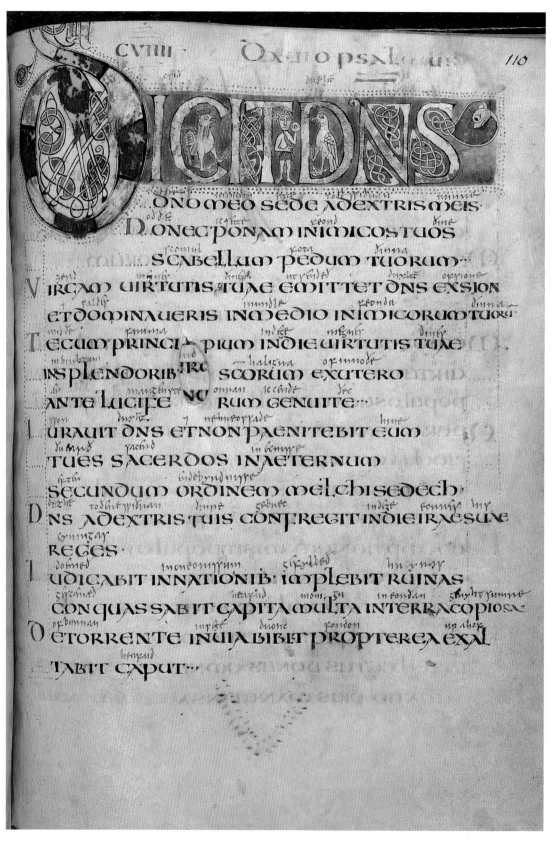

Uncials from the Vespasian Psalter. Canterbury, c. 730.
BL, Cotton MS Vespasian A. i., f. 110.

Vespasian A.i) was the first book on the first shelf under the bust of Vespasian.

In addition to examining and analysing the books of Rome, some of the scribes may even have accompanied their ecclesiastical overlords, such as Benedict Biscop, on their many journeys to the 'eternal city'. They would at least have conversed with those who had done so, or with actual inhabitants, such as John, the Archcantor of Rome, who returned with Biscop to the wilds of Northumbria, along with precious cargoes of books, paintings and relics, to teach Bede and his fellow monks the liturgical chant.

The scribes who joined their monastic brethren in wishing their abbot, Ceolfrith, a tearful farewell on his departure on retirement for Rome in 716, were rewarded for their antiquarian and creative efforts a few years later. Ceolfrith sadly died en route, but the gift of one of his three copies of the Bible which he had taken to present to the Pope reached its destination and elicited a 'thank you' letter to his successor, Abbot Hwaetberht, acknowledging the evident depths of affiliation to Rome. Monkwearmouth/Jarrow had made it into the exalted ranks of the *comitatus* (companions) of St Peter, not least thanks to the labours of its scribes. The exemplar from which Ceolfrith's three Bibles were copied was probably made in Cassiodorus' monastery of the Vivarium. Indeed, the famous figure of Ezra the scribe in the papal copy, the Codex Amiatinus (now preserved in the Biblioteca Medicea-Laurenziana in Florence, MS Amiatino 1), is adapted from a depiction of Cassiodorus himself, his nine-volume edition of the Bible sitting in the book cupboard (*armarium*) behind him (*see* page 39). Not only was the Uncial script faithful to its model, with its elegant spacing 'per cola et commata' (in which

Italian Uncials, from a Gospelbook.
Italy, 6th century.
BL, Harley MS 1775, f.133b.

the length of the line serves to clarify sense), but its text remains the purest witness of the Vulgate. The illusionistic painting-style also convincingly emulated its model – so much so that it was not until a century ago that the Codex Amiatinus was recognised by scholars as the work of Anglo-Saxon rather than Italo-Byzantine craftsmen. This error had been compounded by the fact that whilst at its medieval home, the monastery of Monte Amiato, the dedication inscription recording the presentation to the Pope had been tampered with and abbot Ceolfrith's name replaced with that of a local saint. Succeeding generations of scholars might be forgiven their mistake, however, for the Monkwearmouth/Jarrow essay in antiquarian book production was extremely convincing. Fragments of at least one of the other two copies commissioned by Ceolfrith, one for Monkwearmouth and one for Jarrow, have survived, having been used as binder's waste in comparatively recent times. It seems that one of the copies may have been given by King Offa to Worcester Cathedral during the eighth century, by which time it was already thought to have been made in Rome rather than Northumbria!

Analysing the Script – *Flat Pen Uncial*

This tiny yet elegant script in the Vespasian Psalter forms a dense texture on the page. Letters are only about 3 mm (0·15 in) tall, yet have great impact. Their consistency of form is admirable, and there are few lapses in nib angle or slant. Some letters are constructed from a number of separate strokes and involve a degree of nib manipulation, so it may be better to start practising Angled Pen Uncials first.

The *x-height* is low, only 3 nib widths, with **ascenders** and **descenders**

Enlargement for analysis. Flat Pen Uncials: Note nib angle is measured in degrees from the horizontal. Slant is measured in degrees from the vertical. Because of the consistency of nib and slant angle, only the one variation from 0° is indicated.
The Vespasian Psalter. Canterbury, c. 730. BL, Cotton MS Vespasian A. i., f. 39.

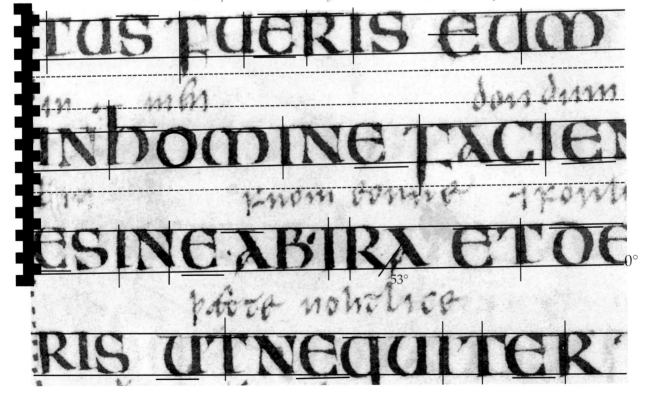

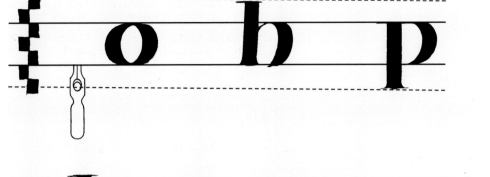

Flat Pen Uncial

Letter height:
3 nib widths; asc-
enders & descenders
4·5 nib widths

Nib angle: 0°,
differs for some
letters

Letter O form:
Round

Slant: Upright

Stroke sequence:
As shown on the
exemplar letters

Speed: Slow

Serifs: Flat with
some constructed
shapes

*Letters which require particular
attention in their construction.
The letter* **A** *is constructed by
making the serifs and downstroke
first with the nib at 0°. The bowl
is made with the nib at 45° and
the hairline stroke with wet ink
and the left-hand corner of the
nib. The letter* **N** *is constructed
by writing the diagonal stroke
first, and then pressing the nib
down within the stroke of the
letter to release ink. Pull this wet
ink down with the left-hand corner
of the nib to make the two down-
strokes. Now construct the serifs,
again using the corner of the nib
to pull the wet ink into the shape.
So, too, with the triangular endings
on the cross-bar of the letter* **T.**

usually just under two nib widths more. With an inter-linear spacing of six
nib widths, this gives the hand an almost ribbon-like appearance stretching
across the page. The Anglo-Saxon gloss takes the eye away from what must
originally have been a most graceful and grand manuscript.

The *nib angle* for most letters is 0°, however, the strokes on some letters,
such as the letter **N,** and **A,** are made with the nib at 90° and 45° respectively.
The nib angle also changes for the construction of some serifs with some pen
manipulation using the corner of the nib to achieve the tiny hairline serifs.

The *shape of the letter O* is a very slightly compressed circle, with a slight
lessening of the curve for the left-hand stroke, which could have been for
speed. This is most marked on the letters **U, D, C** and **E.**

The horizontal nature of the script, with bands of tiny writing stretching
across the page, is in marked contrast to the exceptionally upright nature of
the letter-form, no *slant* at all and with very little variation in any examples.
Uprights are at 0° to the vertical.

Some *serifs* are a single thin stroke, others are built up in a constructed
way which indicates that the hand was written in a slow and careful manner,
with little allowance for *speed,* although there is an obvious flow to the letters.

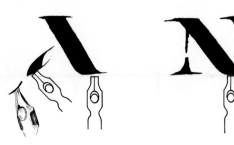

Letters which start with a downstroke

The base of these letters is made by moving the pen to the left at the finish of the stroke, lifting the pen and then making another small stroke to the right.

 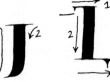 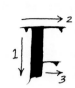 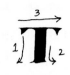 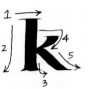

Letters which start with a downstroke and then arch

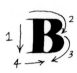 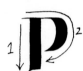 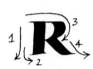 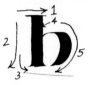

Letters based on the letter O

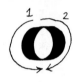 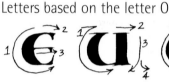 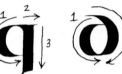 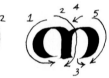

Diagonal letters

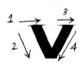 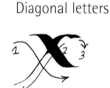

*Use the left-hand corner of the nib to make the long sweeping stroke to the left on the letter **X**.*

Letters which do not fit these families

 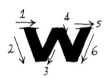

Et ligature

Punctuation marks

Numerals

؛؛؛؛؛!?~ 1234567890

ABCDEᴦᴄhijkLᴍNopqRsᴛᴜvwxyz

Writing Uncials with a flat pen angle.

sed non audierunt eos oues
ego sum ostium
per me siquis introlerit
 saluabitur
et ingredietur etegredietur
et pascua inueniet
fur non uenit nisi ut furetur
 et mactet etperdat
ego ueni ut uitam habeant
 et abundantius habeant
Ego sum pastor bonus
bonus pastor animam suam
 dat pro ouibus
mercennarius etquinon estpastor
cuius non sunt oues propriæ
uidet lupum uenientem
etdimittet oues et fugit
et lupus rapit etdispergit oues
mercennarius autem fugit
quia mercennarius est

et non pertinet adeam deouibͥ
ego sum pastor bonus
et cognosco meas
et cognoscuntme meæ
Sicut nouit me pater
et ego agnosco patrem
Et animam meam pono
 pro ouibus meis
Et alias oues habeo
quæ non sunt exhoc ouili
et illas oportet me adducere
et uocem meam audient
et fiet unum ouile
 et unus pastor
Propter ea me pater diligit
quia ego pono animam meam
et iterum sumam eam
nemo tollit eam ame
sed ego pono eam ame ipso
potestatem habeo ponendi eam

The Stonyhurst or Cuthbert Gospel of St John. Monkwearmouth/Jarrow, c. 698.
BL, Loan MS 74, ff. 46v and 47.

Enlargement of Angled Pen Uncials for analysis.
Note nib angle is measured in degrees from the horizontal. Slant is measured in degrees from
the vertical. The slant is so consistent at 0° that it has not been indicated on the separate lines.
The Stonyhurst or Cuthbert Gospel of St John. Monkwearmouth/Jarrow, c. 698.
BL, Loan MS 74, f. 22.

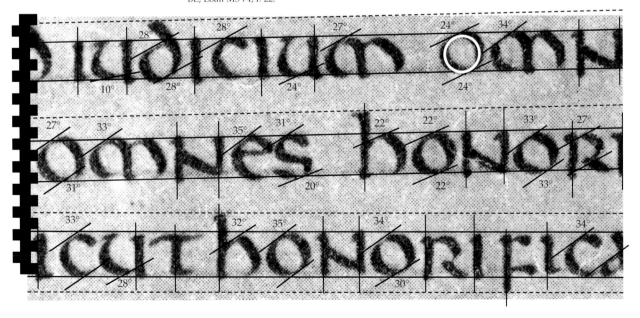

Analysing the Script – *Angled Pen Uncials*

This delightful Uncial script, similar in size to that in the Vespasian Psalter, is tiny, but this time written in a very small, personal book of St John's Gospel. Its almost casual and delicate nature belies a remarkable consistency of slant and form, with a pen nib angle at a more naturally held 20° – 30°.

The *x-height* is very slightly higher than Flat Pen Uncial at 3·5 nib widths, with *ascenders* and *descenders* extending to 5·5 nib widths. As this is a capital alphabet, few letters have ascenders and descenders, **D, F, H, L, P** and **Q** being those that have. We can also add our modern **K** and **Y** to that list. The first downstroke on the letters **N** and **R** does also extend slightly beyond the base line for x-height. Interlinear space is just under 6 nib widths.

The *nib angle* is not so consistent in the enlarged extract shown on page 47, ranging from 10° to over 30°. Maintaining an angle of about 25° will produce letters which are similar to those in this historic manuscript.

The *letter O,* as with other Uncial alphabets, is round, giving the shape to related forms such as **D, C** and **E.**

The consistency of the *slant* at 0° is marked, compared with the varying angle at which the nib was held.

There is very little pen manipulation for this Uncial alphabet, and fewer pen lifts than before. The *stroke sequence* is shown with the exemplar letters.

Serifs tend to be simple hook serifs, used almost as mere entry and exit strokes. However, here and there the scribe has made a little more of this in that there is a more obvious hook to the cross-bar of the letter **T** and a greater emphasis to the exit stroke which suggests a forerunner to the minuscule letter **t** – as shown at the beginning of the third line of the enlargement.

Because the letter construction is more natural and less laboured, with fewer pen lifts and less manipulation of the nib, it is clear that Angled Pen Uncials were written at a quicker pace than Flat Pen Uncials. The *speed* of writing, though, would be moderate, not fast.

Letters requiring particularly careful construction.

*The letter **D** is larger than may be expected for this writing style. It needs care to ensure that it has the look of a slightly forward slant. Look carefully at the counter – white space – on this letter. The letter **M** is extremely wide. Pushing up a flexible quill for the second bow creates a slightly thicker stroke as it leaves the down-stroke. This is almost impossible with a metal pen, so for this stroke move the pen backwards into the downstroke and then make the rest of the curve of the bow. The letter **S** is rather springy. The second and third strokes (top and bottom) curve into the letter, and you will need to pull these strokes round.*

Angled Pen Uncial

Letter height:
3·5 nib widths;
ascenders &
descenders
5·5 nib widths

Nib angle: 25°

Letter O form:
Round

Slant: Upright

Stroke sequence:
As shown on the
exemplar letters

Speed: Moderate

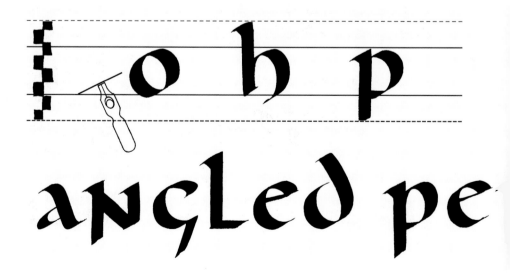

Letters which start with a downstroke

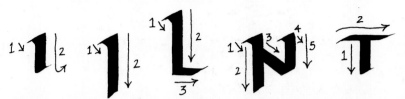

Letters which start with a downstroke and then arch

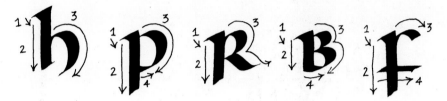

Letters based on the letter O

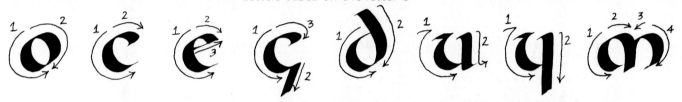

Diagonal letters

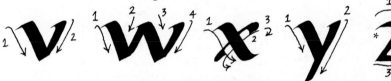

Flatten the nib to 0° for the second diagonal stroke of the letter Z.

Letters which do not fit these families

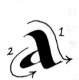 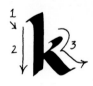 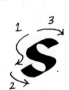

Et ligature

Punctuation marks

;,.'':::!?-

Numerals

1234567890

abcdefghijklmnopqrstuvwxyz

Writing Uncials with the pen nib at an angle.

49

PRAISE him with the sound of the trumpet
PRAISE him with the psaltery and harp
PRAISE him with the timbrel and dance
PRAISE him upon the loud cymbals
PRAISE him upon the high sounding cymbals

Uncials with a flat pen angle above and Uncials with an angled pen below.
The flat pen Uncials have an elegance and grandeur about them which contrasts with a flamboyant
Laudate written in gold. Gold was also mixed with the dark blue paint to give a rich and opulent feel
to the letters.

The Stonyhurst Gospel is the Gospel of St John, so it was fitting to use a verse from this book (John,
chapter 14, verse 27) to show how the hand is written. This writing style has a simple and almost
innocent quality, and so gold and extravagant use of colour would have been inappropriate.

peace I leave with you, my peace I give unto you,
not as the world giveth, give I unto you.
Let not your heart be troubled,
neither let it be afraid.

Half-uncial

St Matthew, depicted, perhaps for the first time, as a scribe in the Lindisfarne Gospels. Lindisfarne, c. 698.
BL, Cotton MS Nero D. iv, f. 208.

In many respects Half-uncial was to prove the most influential member of the Roman system of scripts. It developed alongside its more prestigious parent, Uncial, from the second to fourth centuries AD and combined a rounded aspect with emergent cursive 'lower case' letter-forms with ascenders and descenders. This tendency increased following an exchange of influences between Half-uncial and the New Roman Cursive hand of the reformed Roman bureaucracy of the early fourth century. These two scripts played a formative role in the evolution of the national hands (often termed minuscule scripts) which succeeded those of the Roman Empire. Half-uncial was reinvented and perfected by the 'Insular' scribes of sixth- to ninth-century Britain and Ireland. Somewhat confusingly, the eminent palaeographer E. A. Lowe termed this Insular Half-uncial 'majuscule', to distinguish it from its lower-grade minuscule counterparts. Strictly speaking, majuscule scripts are bilinear and do not feature ascenders and descenders, whereas quattro-linear minuscules do. Insular Half-uncial does include modest ascenders and descenders, although they are not as pronounced as in minuscule, but many of the letter forms do vary and there is an obvious perception that Half-uncial was a higher-grade script, along with Uncial. The technical majuscule/minuscule distinction is therefore not very helpful in this context.

From around the year 800 Half-uncial went on to influence the pan-imperial script of the Carolingian Empire – Caroline Minuscule – which in turn was to provide the foundation for Gothic Book Script (*Textualis*) and the Humanistic hands, and thereby the roman and italic typefaces.

The high-point in the long-lived development of Half-uncial was reached around 700 in the scriptorium of the Columban monastery of Lindisfarne, a tidal island off the coast of the Anglo-Saxon kingdom of Northumbria. Here at least two remarkably gifted artist-scribes were inspired to produce some of the most splendid and innovative copies of the Christian sacred texts – the Durham Gospels, the Echternach Gospels and the *tour de force*, the Lindisfarne Gospels. It is remarkable that, whereas library books copied in the Lindisfarne scriptorium would occupy teams of around half a dozen scribes, these great Gospelbooks were entrusted to masters working alone.

51

The efforts required were heroic, as befitted a culture which could produce a poem which survives, praising a hero-scribe, one Ultan. Whoever undertook such labours would be, either already or subsequently, a highly influential member of the monastic community. The Old English gloss, added to the Lindisfarne Gospels around 970 by a scribe named Aldred, records the community's traditions concerning the production of its leading cult item, and names Eadfrith, bishop of Lindisfarne (698–721) as the artist-scribe. Aethelwold, his successor, is accredited with the binding and Alchfrith the Anchorite with its metalwork adornment. We do not know much about the latter, as anchorites did not espouse a career structure, but the others associated with the work were certainly the most important members of the community of St Cuthbert. The status of the scribal work involved is not inconsistent with their rank, in accordance with the Insular tradition of *opus dei* ('work for God'), but we can only speculate concerning the human costs involved for someone who had to rise eight times each day and night to attend the Divine Office, to engage in prayer, study and manual labour, and, on top of that, to perhaps have to oversee the administration of a large settlement with an additional market function. Bishop or no, the artist-scribe of the Lindisfarne Gospels was certainly a hero. Early medieval scribes would sometimes record in the margins that their fingers would not write for the cold, and the rigours of working in an offshore environment in a community where the physical deprivations of the Desert Fathers had been transported into an inclement northern climate by the hard-bitten ascetics of the Celtic Church, should not be underestimated. At a period when Cassiodorus' precept that 'every word written was a wound on Satan's body' was still in force, these men, and women, were on the spiritual front-line.

The Half-uncial written by the Lindisfarne scribes was elegant and time-consuming to produce. It is distinguished by a breadth and rotundity of aspect and by a rigorous adherence to head and base-lines. A most unusual feature of the Lindisfarne Gospels is that it contains ruling for head lines as well as base lines; an additional sign of its exceptionally high status as a cult object. This Half-uncial could retain a high frequency of Uncial letter-forms. Despite the calligraphic linking strokes which join words in places, the spacing and punctuation are designed to ease legibility. Irish scribes had already done much to address such issues as a result of learning Latin

Insular Half-uncial in the generation after the Lindisfarne Gospels.
A Northumbrian Gospelbook, early 8th century.
BL, Royal MS 1 B. vii, f. 15v.

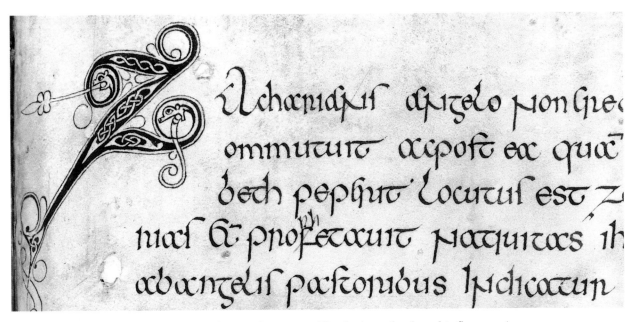

Insular hybrid minuscule, from the Royal Bible, Canterbury, c. 820-40.
BL, Royal MS 1 E vi, f.42.

as a foreign language. The fusion of cultural influences is seen even more markedly in the decoration, where text and image are fully integrated to reinforce one another. Here a full-page decorated incipit is as much an embodiment of the Godhead as an image of the Crucifixion might be and the cultural melting-pot that was the British Isles and Ireland is reflected in an exuberant fusion of Celtic, Germanic and Mediterranean forms.

This level of input of human and physical resources could not be sustained throughout the production of sacred books, and other examples of service-books which were actually used, rather than serving as focal points for major cults and veneration, perhaps give a truer impression of the work produced. Another early eighth-century Northumbrian Gospelbook, BL, Royal MS 1.B. vii, is one such. Its script retains a finesse and elegance, but its decoration is far less ambitious, although it still serves its function of articulating the text admirably. By contrast, no effort is spared in writing the script, which is an elegant version of the 'reformed Half-uncial' of the Lindisfarne Gospels, as practised by the next generation of Northumbrian scribes. Although his decoration is firmly rooted in earlier Germanic styles of ornament, the artist-scribe of Royal 1.B.vii was keen to display his knowledge of Mediterranean culture. Alas, his aspirations somewhat outstripped his ability. In the piece of display script illustrated he has used the 'chi-rho', the first letters of the word *Christ* in Greek which had become a sacred symbol in their own right. However, he has outwitted himself by replacing the Greek 'rho', which looks like a roman **p**, with the Greek 'pi', thereby transforming the phrase into 'Hippy autem' (phonetically) – more 'Godspell' than Greek!

Insular Half-uncial was conservative and long-lived, with perhaps as much as a century separating the similar scripts of the Lindisfarne Gospels and the Book of Kells. However, by the late eighth century less laborious script solutions were being sought for high-grade book production. On the Continent these were to lead to the development of Caroline Minuscule, but in Britain cursive or minuscule scripts were elevated in status, or fused with Half-uncial to produce hybrid solutions which looked good and which were more economical to produce. Such a hybrid minuscule can be seen in the Royal Bible, BL, Royal MS 1.E.vi. This large volume now contains part of the Gospels, but the numbering of its quires and its scale indicate that it was once part

53

The Lindisfarne Gospels. Insular Half-uncial. This is one of the very few pages not to have been fully glossed in Anglo-Saxon minuscule during the 10th century and conveys the original elegance of the script.

Lindisfarne, c. 698

BL, Cotton MS Nero D. iv, f. 208.

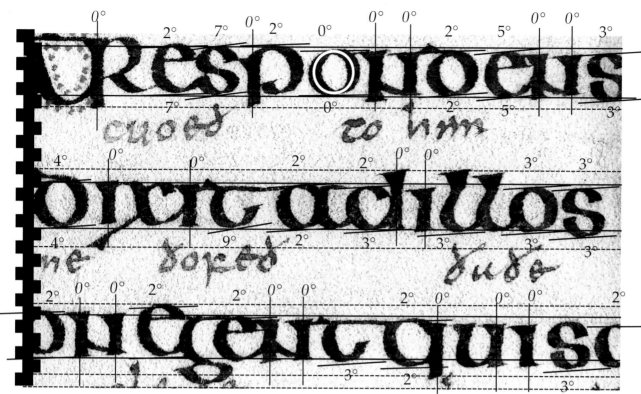

of a massive Bible, on a par with the Alcuin Bibles of Tours. It combines Carolingian influence in decoration with that of the early Christian world and of contemporary Britain, producing a cultural fusion akin to that of earlier Hiberno-Saxon manuscripts, such as the Lindisfarne Gospels, although it looks very different with its purple pages and gold and silver display capitals. It was written in Canterbury around 820–840 on the eve of the Viking invasions which were to bring the Insular 'golden age' to a violent end.

Analysing the Script

This handsome, elegant style shows the development of ascenders and descenders which were to separate minuscule from majuscule alphabets. It was written slowly and carefully with painstaking attention to letter construction.

The impressively large letters were written with a low **x-height** of just over three nib widths, the **ascenders** and **descenders** being only about one nib width longer, apart from the letter **g**, which extends 2·5 nib widths below the base line for x-height.

Writing the Anglo-Saxon minuscule gloss underneath the lines of Half-uncial has given us a different impression from how the manuscript must have looked when it was first finished. The gloss, attractive enough in itself, changes the relationship between the lines of Half-uncial, which is why one of the few pages with only a little gloss was selected for this book and is shown opposite. In fact almost twice the x-height, a space of six nib widths, was left between the lines. This must have made the original, unglossed manuscript very majestic indeed, and is an indication of the precious nature of the book. Leaving this amount of space demanded many more animal skins for the pages than would have been the case if the lines had been placed closer together.

To achieve this graceful yet chunky style, the **nib** is held at a very low **angle.** Completely flat, 0°, for some strokes, but mainly 2° – 3° or less. However,

Right-oblique nib for
writing Half-uncials.

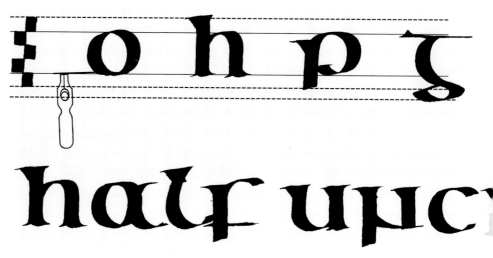

Half-uncial

Letter height:
3 nib widths;
ascenders &
descenders
4 nib widths

Nib angle: 2°

Letter O form:
Round

Slant: Upright

Stroke sequence:
As shown on the
exemplar letters

Speed: Slow

Serifs: Serifs built
up wedge-shaped

Below right:
Letters which require partic-
ularly careful construction
The first stroke of the letters **d, g**
and **t** is formed by slightly rotating
the nib upwards, using the left hand
corner as a pivot. With a quill this
makes the slightly concave inden-
tation which is more challenging
with a less flexible metal nib. The
wedge shaped serifs on letters such
as **i, n, l** and **b**, are constructed
by moving the pen to the right and
downwards, and the foot of the
letter made by moving the pen to
the left as you take the nib from
the page, lifting the pen and then
making an extra separate stroke to
the right. Both strokes are almost
hori-zontal, with very slight
curves. The letter **x** is unusual in
that the fourth stroke, down and to
the left, has a similar concave
ending ref-lecting that of letters **d**
and **g.** This time it may be easier
to achieve this effect by using the
corner of the nib to make a
separate stroke.

some strokes in the example selected show a pen angle of 5° – 7°. It is interesting to note how the nib angle becomes more consistent in the third line. This may be for a number of reasons; often it is because the scribe is settling into the hand and is concentrating more. However, it is also an indication of the care needed in taking a small sample of an historical manuscript as a perfect exemplar. An angle of about 2° – 3° for the strokes gives the letter-shapes to provide the flavour of this elegant and graceful script. It is possible, indeed probable, that the scribe wrote with a quill cut to a right oblique nib, as the wrist needs to be twisted round to the right and the elbow kept close to the body for the nib angle to be maintained in this way.

The *shape of the letter o* is almost a perfect circle, with an oval white space, or counter, contained within the strokes for the round letters. Note how this counter changes shape when the nib angle is a little steeper than 0°, as in the letter **d** on the first line in the enlarged extract on the previous page.

The *slant* of letters is a consistent 0° from the vertical, upright, with very little variation in the example shown. Scribes will appreciate how challenging it is to maintain that consistent perpendicular nature to the uprights.

The *stroke sequence* is careful and almost laboured; serifs are formed with meticulous care. Entry serifs are written with a stroke downwards to the right followed by the stem of the letter, which usually has a slight entry stroke from the right to the left also. Base serifs are made by moving the pen to the left as it is taken from the writing surface, and then an extra stroke made to the right in a similar way.

Because of the separate nature of the individual strokes and the built up serifs the *speed* at which this hand is written is slow.

Serifs in the Half-uncial hand are built up and wedge-shaped. In some letters in the enlargement shown on the previous page the construction of the serifs can be discerned. The first stroke downwards and to the right protrudes very slightly beyond the second straight stroke. This can be seen in the **n** almost in the middle of the first line, the curved letters **l** in the second line, and the **u** at the end of the third line.

Letters which start with a downstroke

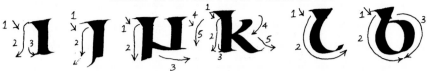

*The downstrokes on the letters **l** and **b** curve slightly to the left.*

Letters which start with a downstroke and then arch

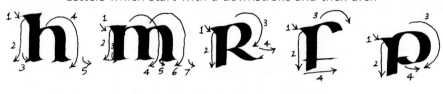

*The entry serif for the letters **r** and **f** start on the top line for x-height, with the arch rising above this. The entry serif for the letter **p** is lower, and the arch just touches to the top line.*

Letters which start with a stroke to the left

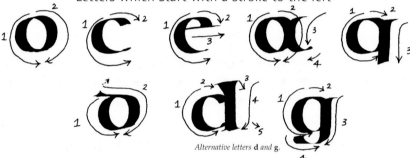

*Alternative letters **d** and **g**.*

Letters based on the letter u

Diagonal letters

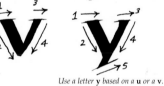

*Use a letter **y** based on a **u** or a **v**.*

Letters which do not fit these families

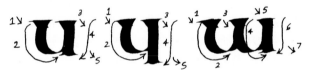

Et ligature

Punctuation

Numerals

.,:;!?"" 1234567890

abcoefᵹhijklmnopqꞃꞅtuvwxyz

Writing Half-uncial

57

Ꝺoꞷn Cuthbert went towards
the beach beneath the monastery
and out into the sea until he
was up to his arms and neck
in deep water. the splash of the
waves accompanied his vigil
throughout the dark hours of the
night. at daybreak he came out
knelt down on the sand and prayed.
then two otters bounded out of the
water stretched themselves out before
him, warmed his feet with their
breath, and tried to dry him on their
fur. they finished, received his blessing
and slipped back to their watery home.

The Lindisfarne Gospels, on which this style of Half-uncial is based, was written for God and St Cuthbert by Eadfrith. It seems appropriate, therefore, to use this writing style for a story about St Cuthbert and his affinity with the natural world. The strong Christian basis on which the community at Lindisfarne was founded is indicated by an embossed Celtic cross which seems to be shining out through the grey-green sea mist.

Insular Minuscule

St Luke, from the Book of Cerne, Mercia (Lichfield?), c. 820–40. Cambridge, University Library, MS Ll. 1.10, f. 21v.

Document recording the Synod of Clofesho, Christ Church, Canterbury, 803. BL, Cotton Ch. Aug. II. 61.

By 700 the scribes of Britain and Ireland had developed a whole hierarchy of scripts, from display capitals down to cursive minuscules, based on the assumption that it was not appropriate to use the same grade of script for a note as for a Gospelbook. Lower-grade scripts were not necessarily any less sophisticated than their higher grade counterparts were are characterised by a similar concern with clarity and legibility, coupled with a love of calligraphic detail.

In the aftermath of the Roman Empire, the scholars and scribes of the Irish and British Churches invented their own system of scripts, referring to those of the Roman past, but not being directly influenced by their full spectrum. From the middle-grade hand of the educated person of late Antiquity, which has been termed cursive half-uncial or quarter uncial, they reinvented Half-uncial for formal purposes and more rapidly written cursive variants for less formal circumstances. Thus Insular minuscule was essentially derived ultimately from a watered-down version of Half-uncial. Because of the administrative disjuncture following the Roman withdrawal in the early fifth century, it escaped the influence of the progressively vulgarised administrative hand of the Empire (known as New Roman Cursive) which was producing the spidery excesses of Merovingian cursive in Gaul. This having been said, loops, ligatures and reversals of ductus were all employed to speed up writing, and in so doing became stylistic features.

The flourishing Christian culture of the Anglo-Saxon and Celtic Churches engendered a great demand for books, at home and in the Continental mission fields. Bede's monastery of Jarrow, with its twin Monkwearmouth, produced a particularly elegant minuscule script during the first half of the eighth century to cope with the widescale publishing programme which was called for by the immediate demand for copies of Bede's works, especially his *History of the English Church and People*, several of which have survived (such as the St Petersburg Bede, the Moore Bede in Cambridge University Library and BL, Cotton MS Tiberius A. xiv). The example from Cotton MS Tiberius A. xiv reproduced here demonstrates the fluidity,

59

legibility and elegance which could be achieved in a cursive script which was designed as a book script as well as for more everyday purposes. As a scholar Bede probably wrote such a script himself, although it should be remembered that it was common practice for authors to dictate their works rather than pen them themselves.

At its most formal, Insular minuscule is referred to as 'set' rather than cursive, because of the heightened number of pen-lifts. If Half-uncial letter-forms, notably an 'oc' shaped **a,** figure then the script might even be termed a hybrid minuscule (*see* page 51, Half-uncial), this being a script which aimed at the effect of Half-uncial without the input of effort and which built in certain minuscule features to enhance the overall calligraphic effect. This tendency to elevate minuscule to a higher status was particularly prevalent from the late eighth century onwards, coinciding with the parallel development of Caroline Minuscule on the Continent. Good examples of set minuscule may be seen in some of the devotional collections put together to assist individuals in their private prayer in southern England during the early ninth century (known as the 'Tiberius Group' prayerbooks). Some of these show signs of having been written by or for women, notably the Royal prayerbook, BL, Royal MS 2.A.xx, which focuses upon Christ as the healer of humanity. It features prayers and charms with a medical emphasis along with some of Christ's miracles of healing, many with a female slant (the woman with the flow of blood, Jairus' daughter etc.). The language also slips into the feminine voice in places. Perhaps this book was written in a nunnery in the Anglo-Saxon kingdom of Mercia by or for a woman physician.

Script could carry definite political overtones as was demonstrated by the way in which it was used as part of a legal conflict over authority between the Archbishop of Canterbury and the King of Mercia, again during the early ninth century. The predatory King Offa (757–796) who was rapidly extending his authority over the other Anglo-Saxon kingdoms, had wished to have his son crowned as co-ruler during his lifetime, an unorthodox step which the Archbishop refused to implement. In typical fashion, Offa promptly created a new, more compliant Archbishopric at Lichfield. Offa's successor, King Coenwulf, and Archbishop Wulfred of Canterbury spent a quarter of a century, with papal intervention, sorting out the aftermath of this action, relegating Lichfield and arguing about the degree to which rights and property should be restored to Canterbury. Litigation flourished, and as part of this the formidable Wulfred, himself a wealthy and powerful Mercian nobleman, and his fellow scribes in the Christ Church scriptorium, devised a prestigious cursive minuscule distinguished by fanciful letter-forms featuring ligatures, monograms and calligraphic flourishes. This represented a consciously formulated house style (which has been termed 'mannered minuscule') designed to bolster the prestige of documents produced by Christ Church. It was also used for books, such as a Saints' Lives, BNF, MS lat. 10861, and by comparing hands in dated documents and books it has been possible to attribute and group some of the books of the period for which the date and place of origin was unclear. Archbishop Wulfred's strategy worked and for the first time he was able to walk into a court brandishing an imposingly written charter and to proclaim the superiority of written evidence at law over centuries of oral witness. The power of the written word was fully established – and immediately forgeries proliferated. The example reproduced here, BL, Cotton MS Augustus II.61, is a record of the Synod of Clofesho of 803. This was an important ecclesiastical meeting at which Offa's archbishopric of Lichfield was dismantled and many of

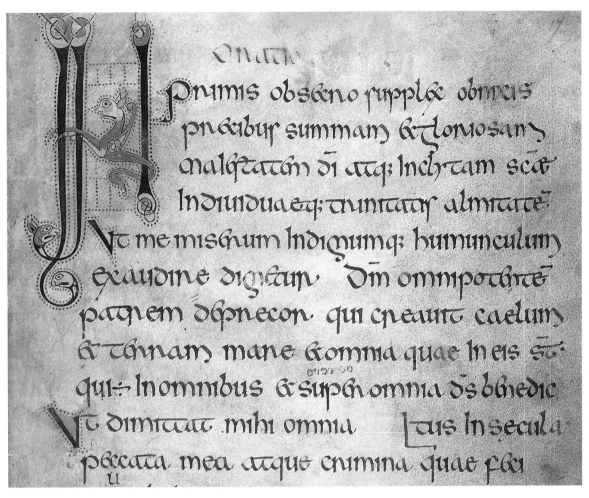

Insular set minuscule, from a prayerbook belonging to the 'Tiberius' group. Mercia, early 9th century. BL, Royal MS 2. A.xx f. 36.

Canterbury's privileges restored. It marked the beginning of the southern English Church's challenge to royal and lay control and was produced in the form of a charter. At this period copies of legal disputes and of meetings were produced in monastic scriptoria by, or on behalf of, the recipient or major interested party.

So successful was Insular minuscule that Celtic and Anglo-Saxon scribes were reluctant to relinquish it, indeed it was in use in Ireland in the early twentieth century. The tide of the multi-purpose Caroline Minuscule which swept across the Continent during the ninth century, along with Carolingian rule, did not initially cross the Channel. Not until the Benedictine reform of the English Church along continental lines in the later tenth century did Caroline come into regular use, and then only for texts in Latin, with Anglo-Saxon Minuscule, descended from its Insular forebear, remaining in use for Old English – a distinctively English compromise. Sometimes the two scripts occur side by side, in bilingual translations or in documents with their texts in Latin but the description of the physical boundaries of land in Old English. Anglo-Saxon Minuscule continued in use until around 1150 but underwent several changes in appearance. The initially pointed aspect survived the traumas of the Viking invasions of the ninth century and was used as part of Alfred the Great's revival of learning in the late ninth century. This gave way to a squarer appearance from the second quarter of the tenth century and then to a rounded aspect, under the influence of Caroline Minuscule, from around 1000.

Document recording the Synod of Clofesho, Christ Church, Canterbury, 803.
BL, Cotton Ch. Aug. II. 61.

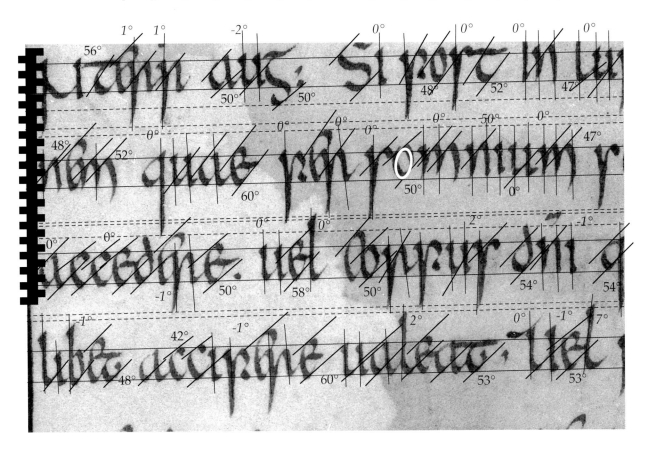

Enlargement for analysis.
Note: nib angle is measured in
degrees from the horizontal; slant
of letters is measured in degrees
from the vertical and is shown in
Italics.
Insular pointed minuscule. Bede.
History of the English Church
and People, *Monkwearmouth/*
Jarrow. c. 740–50.
BL, Cotton MS Tiberius A. xiv. f. 32.

Analysing the Script

Insular Minuscule is a script which was adapted by writers for their indi-
vidual use, resulting in a number of variations in letter formation, style,
heights of letters and angle of pen nib. For this reason, it is best to study
as many manuscripts as possible and make your own judgements regarding
the letter-forms. There are even changes to letters within one manuscript
as can be seen in the examples in this chapter.

The enlarged writing in the Cotton MS Tiberius A. xiv extract above is a
flowing, easy, style which must have been a joy to write after the laboured,
carefully constructed serifs and letters of Half-uncial.

The *x-height* of about four nib widths, together with the *ascenders* of
seven nib widths and *descender* height of anything up to ten nib widths
produces a writing style which is not only comfortable to write but also
easy to read. The eye flows over this flowing hand. There are anomalies
in the heights of ascenders and descenders, though. The letter **d** is shorter
than that of other similar letters, having an ascender height of between
five and six nib widths. The letter **g,** too, does not extend as far as other
letters, the lower bowl of this letter being tucked well into the space just
below the lower line for x-height, and the whole letter extends to six nib
widths only. However, other descenders do descend, and that long stroke is
constructed by turning the nib whilst writing until it is almost vertical. This
results in an extended tapering shape to the letter which adds to the narrow,
upright nature of the hand. Unusually, the letter **e** is contained within the
lines for x-height in some places, but written so that part of the letter is above
the line in others. This is most marked when there are ligatures between **e**
and other letters. We are used to this with the letters **e** and **t** making an

Extract from the line below that
in the above manuscript, showing
the letter **y** *in the word* **mysteria***.*
This gives the key for the family of
modern diagonal letters.

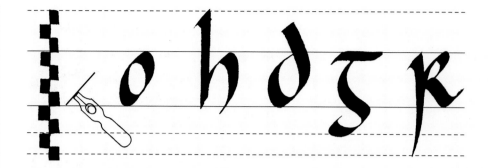

Insular Minuscule

Letter height:
4 nib widths; asc-
enders & descen-
ders 7 – 8 nib
widths. Letter
g 6 nib widths

Nib angle: 45° –
50°

Letter O form:
Upright oval

Slant: Upright

Stroke sequence:
As shown on the
exemplar letters

Speed: Moderate-
ly fast

Serifs: Simple
built up club-
shaped, exit
strokes minimal

*To make the long tail, characteristic
of Insular Minuscule, gradually
turn the nib so that the angle
changes from 48° to almost 90°.*

ampersand in later manuscripts, but in the Cotton Tiberius manuscript the
letter **e** is linked to **r, p, l, m, d** and even **a.**

The *angle* at which the *pen* was held varies, as it does when writing ord-
inarily today. The angle changes from about 40° to 60°, with an average of
about 48°. This is quite a steep angle and it may help if you draw guide
lines at this angle when first writing this style.

The upright, oval *shaped letter o* contributes to the compressed style of
Insular Minuscule – the contrast between the compression of this hand and
the wide and round style of Half-uncial being marked in the Lindisfarne
Gospel extract on page 54. This gives the shape and width to many letters
but not all. The letter **d**, for example, is formed from a narrow oval shape,
but is constructed so that it has a decided forward slant. The letters **a** and **q**
take a different form. The belly of both letters sags considerably towards the
left. In the extract many letters **a** remain without the construction strokes joined
at the top. For the letter **q,** a wedge-shaped serif forms part of the join between
the bowl of the letter and the downstroke.

Some letters *slant* forwards, some slightly backwards and some remain
upright, while in some cases the angle of the stroke varies within one letter.
The general feel of the hand, though, is of an upright nature.

The *stroke sequence* is shown on the following page. Letters are written in
a relaxed manner, and although not many letters join – apart from the letter
e which seems to join to almost every other letter – there is a feeling of haste
about this hand. It is likely that it was written at a moderate to fast *speed*.

Letters show slight exit strokes, sometimes slightly curved and extending
below the baseline for x-height as in the letter **h** and **m**, and there are pro-
nounced wedge-shaped *serifs*. These are formed by moving the nib downwards
and to the right, making a stroke which is the thickness of the nib. The pen
is then lifted and the downstroke written. The most marked feature of the
hand is not the serifs but that long extending downstroke on descenders.

Letters which start with a downstroke

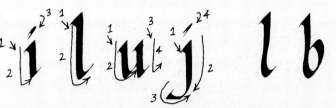

*Letters **l** and **b** may have straight downstrokes*

Letters which start with a downstroke and then arch

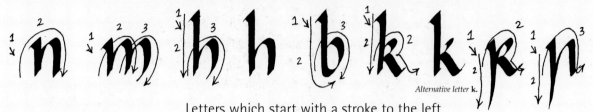

*Alternative letter **k**.*

*Alternative letter **r**.*

Letters which start with a stroke to the left

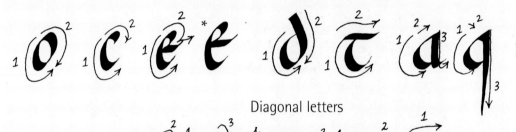

** Some letters **e** are contained within the lines for x-height, but many are larger.*

Diagonal letters

Letters which do not fit these families

*Alternative letter **s**.*

Et ligature

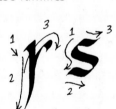

Punctuation

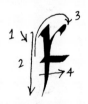

Numerals

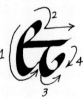

123456789 0

abcdefghijklmnopqrstuvwxyz

Writing Insular Minuscule.

In enemy
ended my life

deprived me of my physical strength:

then he dipped me in water and drew me out again,

and put me in the sun,

where I soon shed all my hair.

After that, the knife's sharp edge bit into me

and all my blemishes were scraped away;

fingers folded me and the bird's feather

often moved over my brown surface,

sprinkling meaningful marks;

it swallowed more wood-dye and

again travelled over me leaving black tracks.

Then a man bound me, he stretched skin over me

and adorned me with gold;

thus I am enriched by the wondrous work of smiths,

wound about with shining metal.

The Anglo-Saxons were fond of riddles. This translation of an Anglo-Saxon riddle has the answer hidden behind the lines.

Caroline Minuscule

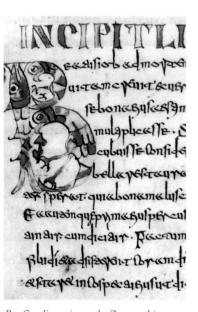

St Matthew, from the Harley Golden Gospels, Charlemagne's Court School, c. 800.
BL, Harley MS 2788, f.13v.

Pre-Caroline minuscule; Zoomorphic initial **B**, *from a copy of Gregory the Great,* Commentary on Job. *N. France (Laon?), mid-8th century.*
BL, Add. MS 31031, f. 55v.

The solutions to finding a workable script for other than *de luxe* purposes elsewhere in what had been the western provinces of the Roman Empire were varied and achieved different degrees of success. Like Britain and Ireland, the Duchy of Benevento in southern Italy and Visigothic Spain produced legible and long-lived minuscules of their own. Some monastic scriptoria, such as St Gall in Switzerland, Bobbio in northern Italy, Echternach in Luxembourg and Fulda in Germany, were heavily influenced by Insular scripts, reflecting the intervention of Insular missionaries. In Gaul certain important monastic centres, such as Luxeuil and Corbie, came up with their own minuscule cocktails of Half-uncial and cursive elements. An example of Luxeuil minuscule is reproduced here from BL, Add. MS 31031, a copy of Gregory the Great's *Commentary on Job* made perhaps at Laon during the eighth century. The influence of New Roman Cursive can be clearly seen in its ligatures, loops, loosely formed letters such as the open-headed **a** and the attenuated ascenders and descenders.

From Corbie 'ab minuscule', with its distinctive open-headed **a** and open-bowed **b** resembling a tall **t**, evolved 'Maurdramnus minuscule' (named for the abbot, Maurdramnus, *c.* 772–781). This simplified script, along with an injection of Half-uncial and Insular influence, formed the basis for Caroline Minuscule. In addition to the more standardised letter-forms, Caroline also featured fairly consistent use of the ampersand (**&**), a rapid version of the older **et** ligature, and a more sophisticated range of punctuation marks, including hyphenation, the *punctus versus* which resembles a semi-colon and the *punctus interrogativus* or question mark, as well as the basic point or *punctus*.

An early example of Caroline, perhaps produced in the diocese of Reims in the late eighth century, is seen here in BL, Harley MS 2797. This is written entirely in gold, a technique known as chrysography. The imperial connotations of the use of gold, silver and purple were well established by this time. They were reminiscent of the ancient Roman and Byzantine Empires and aptly reflected Charlemagne's own imperial ambitions, as well as being an eminently suitable medium for the word of God. Earlier, in 735–6, the English

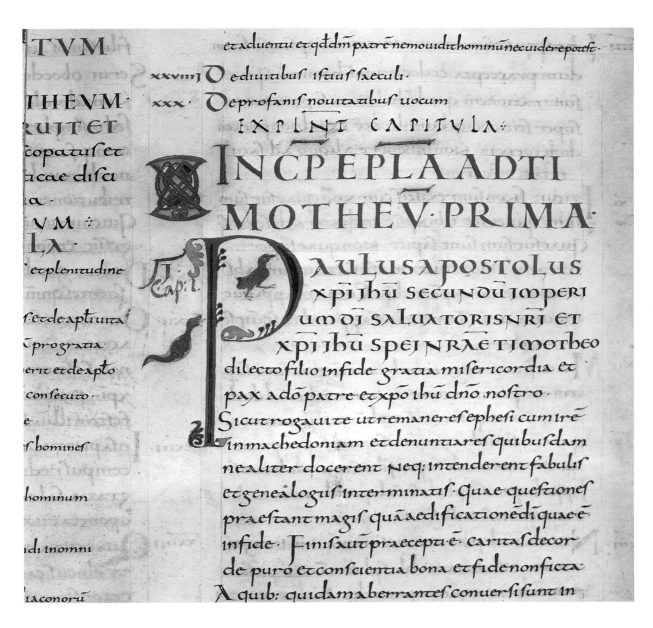

A descending hierarchy of scripts, from Square Capital titles to Rustic rubrics, through Uncials to Caroline Minuscule for the text. From the Moutiers-Grandval Bible, one of the great Tours Bibles, c. 840.
BL, Add. MS 10546, f. 434v.

missionary to Germany, St Boniface, had written to Abbess Eadburh of Minster-in-Thanet expressly requesting that she and her sisters provide him with copies of Scripture penned in gold to 'wow' the natives ("...write for me in gold the epistles of my lord, St Peter the Apostle, to secure honour and reverence for the Holy Scriptures when they are preached before the eyes of the heathen … I send the gold for writing this"). The more sophisticated audiences of the Carolingian Empire were no less susceptible to such a visual impact and obvious consumption of material resources.

The remarkable success story of Caroline is largely due to the fact that it was politically sponsored (rather as 'pinyin' was promoted in Communist China earlier this century). Its patron was Charlemagne who in his famous proclamation of 789 (the *Admonitio Generalis*), issued even before his coronation as Emperor in 800, set about turning a string of military conquests into something approaching an homogeneous kingdom through the agency of religious and cultural uniformity. In this ambition he was encouraged and aided by a circle of scholars and advisers, of whom Alcuin, who had

been head-hunted from York, was the *éminence grise*. A programme of fostering learning and education and of producing authorised versions of religious texts and disseminating them throughout the Empire was implemented, using a similarly standardised – Caroline – script which was multi-purpose.

The wellspring of this movement was the imperial palace at Aachen, where scholars, scribes and artists were assembled to participate in this ambitious endeavour. Their work and some of the key personnel were then sent to other centres, such as the monasteries of Tours and Orléans, which continued the process of exporting books and influences. At Alcuin's own monastery at Tours a production line was established of teams of scribes and artists working in close collaboration to turn out several massive Bibles per year – the famous Tours or Alcuin Bibles. A sample from one of these, the Moutiers-Grandval Bible, BL, Add. MS 10546, written at Tours around 840, is reproduced here. Its display scripts descend from Square and Rustic Capitals through Uncial to Half-uncial at the major text openings. Thereafter the text is written in Caroline by a number of scribes. The need to work quickly and to produce the most impressive and classicizing effect, in conscious reference to the former imperial glory of Rome, was paramount. The characteristic picture of the medieval monastic scriptorium, with teams of scribes, artists, correctors and binders working under a scriptorium master may perhaps be said to have come into full being at this time. This was still undoubtedly the work of God, but also of Man, with his political and cultural aspirations.

Caroline spread rapidly throughout those areas under Carolingian rule. Rustic Capitals and Uncials were retained for display purposes, and sometimes for really important complete works, such as the influential Utrecht Psalter, copied in Rustics at the monastery of Hautvillers in the diocese of Reims around 830, probably from an early Christian exemplar. This volume is particularly important because we have several surviving 'copies', or rather versions, of it made in England from around 1000 onwards. These include the Harley Psalter and the Eadwine Psalter, themselves influential monuments of Anglo-Saxon and Romanesque book production. When considering most manuscripts scholars will hypothesise about a 'stemma' or family tree, but it is unusual to be able to compare works with their sources in such a direct manner as we can in this instance. The sophisticated and extensive programme of inter-related text and illustration also made this an important model, although subsequent scribes and artists were to experience difficulties in adapting its layout to accommodate their own textual variants and different scripts (*see* English Caroline Minuscule, page 75).

Although Romanesque, or Protogothic, and Gothic book scripts seem very different in appearance from the simple, rounded Caroline the letter-forms are essentially the same. The differences are largely due to a change in aspect (more oval for Protogothic and squarer for Gothic) and to the amount of detail lavished on the heads and feet of minims. When the Italian Humanists of the Renaissance sought to free themselves from the excesses of Gothic script and its connotations of Germanic rule, it was to Caroline Minuscule that they turned as a model. It is ironic therefore that it should have been the product and instrument of the very imperial overlordship from which they sought liberation.

The Humanistic use of Caroline as a basis for their script reforms meant that it also served as the ultimate source of inspiration for the early Roman and Italic typefaces. Its forms have played an incredibly long-lived role in western book production and are familiar to us still.

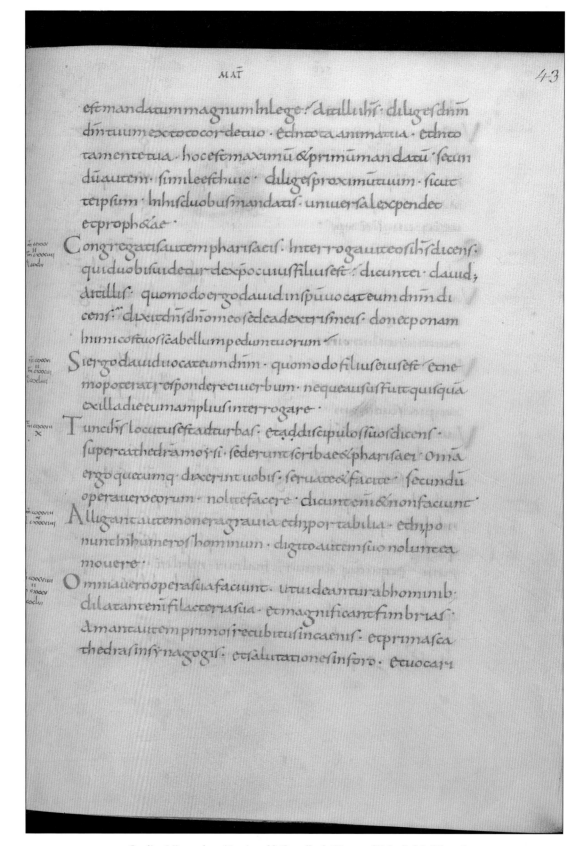

Caroline Minuscule written in gold. Gospelbook. Diocese of Reims?, late 8th century.
BL, Harley MS 2797, f. 43.

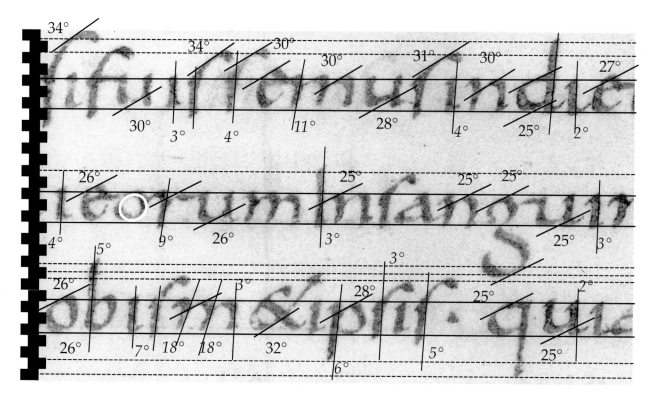

Enlargement for analysis.
Note: nib angle is measured in
degrees from the horizontal; slant
of letters is measured in degrees
from the vertical.
Caroline Minuscule written in gold.
Gospelbook. Diocese of Reims?,
late 8th century.
BL, Harley MS 2797, f. 44.

Analysing the Script

Caroline Minuscule is a flowing, cursive style, which, in this example, is almost like modern handwriting and there is a most attractive fluidity and movement to the hand. It seems as though the scribe was enjoying writing so much that consistency of slant and nib angle have not always been maintained. This is in marked contrast to the studied and careful precision in the construction of letters using a number of strokes and pen lifts in some earlier hands such as those in the Vespasian Psalter or the Lindisfarne Gospels.

The *x-height* of the letters in Caroline Minuscule is low, only three nib widths, but that of *ascenders* and *descenders* at 7 nib widths, is more than the body height. This gives an elegance to the hand. The heights, though, vary, in that the ascender of the long letter **s** is lower than that of other ascenders, and the descender on the letter **g** is so long that it could clash with ascenders in the following line.

There is also variation in the *nib angle,* from 25° to 34° in the extract. This is in keeping with the variations in nib angle and hand position of modern handwriting. An angle of about 27° will achieve letters similar to the manuscript.

The *shape of the letter o* is the key to the letter-shapes in Caroline Minuscule. It is a squashed circle, rather like a grapefruit and it is this shape which results in the extended bowls of the letters **d, p** and **q**, and the rounded arch shapes for the arched letters such as **n, h, m, p** and **h**. These arches are rounded almost as a precursor to Romanesque arches. They are not asymmetrical as in the later Italic hand. Forming this shape is quite easy using a light quill, which can be pushed upwards without spraying ink; it is more challenging with a wide metal nib, and it may be more successful if the first part of the arch is made back downwards to the left before making the second part of the arch to the right, round and down. This does not help the

71

Caroline

Letter height:
3 nib widths;
ascenders &
descenders 6 – 7
nib widths

Nib angle: 27°

Letter O form:
Flattened round

Slant: 5°

Stroke sequence:
As shown on the
exemplar letters

Speed: Moderate

Serifs: Serifs built
up club-shaped

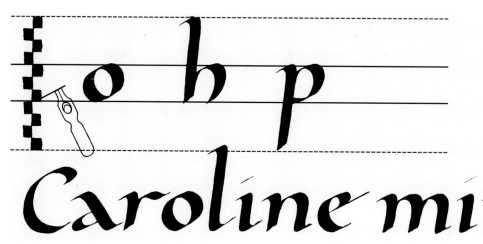

Below right:
Letters which require partic-
ularly careful construction.
*The letter **n** is the key to many*
letters in this alphabet. Look care-
fully at the arch shape. It is not
asymmetrical as in Italic. That un-
*usually curly tail on the letter **g***
may cause you some problems, and
you could choose to make the tail
a little flatter and more modern look-
ing. The heavy serifs on the asc-
enders may be constructed by two
strokes, the first moving downwards
and to the right and then the down-
stroke, or with the nib pushed up-
wards, and the serif and downstroke
constructed in one. The one-stroke
construction is more likely as a
flexible quill can be pushed up for
this stroke, but a metal nib may
resist this stroke.

rhythm and flow of writing the letters, but it does make for a successful letter-shape. Alternatively, scribes who find this a difficult letter-shape to achieve may try cutting and writing with a quill which is, of course, featherweight! (*See* pages 9 – 10)

　　In the extract shown, the ***slant*** varies from 2° to 18°, although is most usually at about 5°. The greatest slant is in the letter **m** on the third line, which has so much movement in it that it looks as if it is about to crash into the ampersand. The reason for this, and the lack of consistency of slant and pen angle, may be due to the medium used for writing. The finely ground particles of gold in the ink are heavier than the medium. It is important when writing in gold ink to maintain a reasonable speed as the particles fall to the bottom of the nib and the medium dries quickly making writing difficult.

　　From an analysis of the hand, and even from a cursory glance at the manuscript extract, it seems clear that this hand was written with a degree of ***speed***. This is despite the grand nature of the book, written completely in gold (chrysography).

　　Serifs in this particular manuscript are of two sorts. First there are small beginning and ending strokes to the letters, such as on **u, n** and **m** – some so small that they are hardly discernible, and formed as the pen was placed on or lifted from the vellum. Others, on the ascenders, are very slight club serifs, nowhere near as pronounced as those on other Caroline manuscripts. There are two ways in which these serifs are formed. The easier and more likely way is that the quill was pushed upwards and slightly to the left, and then the downstroke was made, tidying up any raggedness at the start of the first stroke. Or, the first stroke was made from the top, down and slightly to the right, the pen lifted and then the downstroke made. In my trials with these serifs, and using a quill, I find it is much quicker and easier to push the pen upwards to make the letter-shape, and this also gives the slightly less well defined edge at the top of the letter. Pushing a wide metal pen nib upwards may again be challenging, though, and when first practising this stroke, you may choose to adopt the two-stroke method.

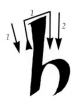

Write the serif in one stroke if you can, pushing up as shown, or in two strokes.

Letters which start with a downstroke

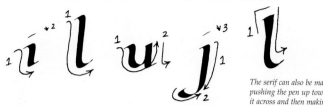

The serif can also be made in one stroke by pushing the pen up towards the left, moving it across and then making the downstroke.

Letters which start with a downstroke and then arch

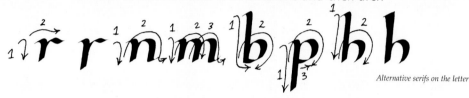

*Alternative serifs on the letter **h**.*

Letters based on the letter o

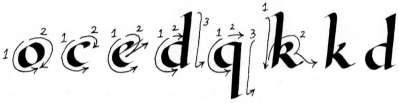

Diagonal letters

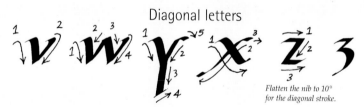

Flatten the nib to 10° for the diagonal stroke.

Letters which do not fit these families

Ampersand

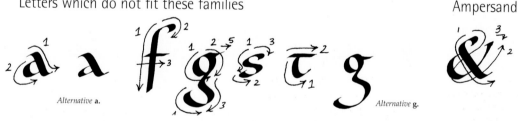

*Alternative **a**.*

*Alternative **g**.*

Punctuation marks

Numerals

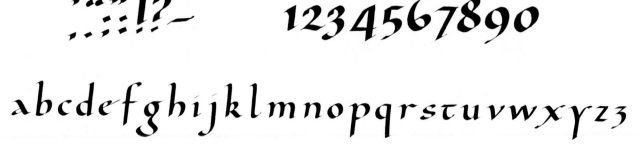

Writing Caroline Minuscule.

73

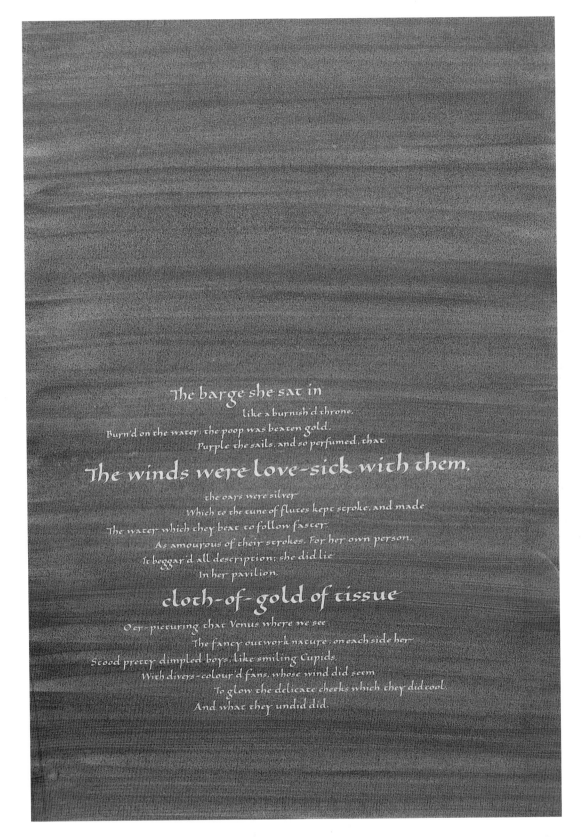

The barge she sat in
like a burnish'd throne,
Burn'd on the water; the poop was beaten gold,
Purple the sails, and so perfumed, that

The winds were love-sick with them,

the oars were silver
Which to the tune of flutes kept stroke, and made
The water which they beat to follow faster,
As amorous of their strokes. For her own person,
It beggar'd all description; she did lie
In her pavilion,

cloth-of-gold of tissue

O'er-picturing that Venus where we see
The fancy outwork nature; on each side her
Stood pretty dimpled boys, like smiling Cupids,
With divers-colour'd fans, whose wind did seem
To glow the delicate cheeks which they did cool,
And what they undid did.

Caroline minuscule was used during the time of the Emperor Charlemagne. It feels appropriate to write this hand using the imperial colours of purple and gold. Another great ruler was Cleopatra of Egypt, and it seems in this extract from Shakespeare's Antony and Cleopatra *that purple and gold suited her, too.*

English Caroline Minuscule

Eadui Basan's self-portrait from the Eadui Psalter.
Christ Church, Canterbury,
c. 1012–23.
BL, Arundel MS 155, f. 133.

The last quarter of the tenth century witnessed a reform of the varied practices permitted by the English Church in favour of a more uniform monasticism governed by the Rule of St Benedict, as practised on the Continent. The three great reformers, Sts Dunstan, Ethelwold and Oswald, had all spent considerable amounts of time abroad and the exchanges of influences and personnel stepped up apace. Caroline Minuscule was introduced for Latin texts, and scribes in future had to be able to write both that hand and their indigenous Anglo-Saxon Minuscule for Old English, often side-by-side in bilingual texts. They also functioned as notaries, attending legal proceedings and recording transactions. The royal house also called upon them for the production of documents and of prestigious volumes used by royalty or bestowed as diplomatic gifts.

The detailing favoured in indigenous scripts seems to have led to the major differences between English and Continental Caroline. In the latter minims terminate simply on the line, whereas in England feet are applied to minims, and serifs often occur (as an extension to the cross-stroke of **e**, for example). Variant letter-forms, such as the single compartment pointed **a** and the flat-topped **g,** also figure.

The most flamboyant exponent of these English calligraphic features was one Eadui Basan (Eadui 'the fat'), a monk of Christ Church Canterbury. We know that he was at work during the first thirty years or so of the eleventh century because he wrote a number of charters dated within those years. He seems to have been frequently withdrawn from the community to serve the King in this capacity and seems to have caught the royal eye for some of the most extravagant book commissions of the age. King Cnut (Canute) and his queen, Emma, who had been married to his predecessor, Ethelred Unraed, the 'ill advised', had a lot of catching-up to do in the opinion polls, following the renewed Viking attacks which brought Cnut to the throne. As part of their policy of appeasement they became avid patrons of the arts, using gifts to curry favour. Some of the elaborate Gospelbooks and Psalters commissioned at this time, such as the Grimbald Gospels

75

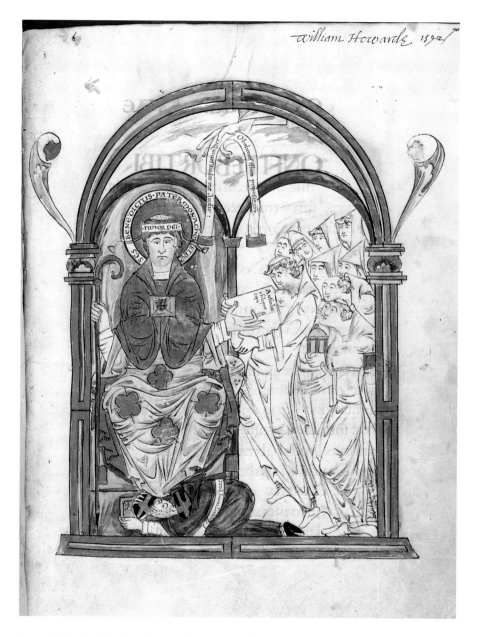

(BL, Add. MS 34890) feature the work of Eadui Basan (*see* page 82). If a poem by Eadui's contemporary at Christ Church, Aelfric Bata, indeed relates to him it would seem that Eadui became something of a 'rock star' scribe, spending too much time 'on the road' and earning a fortune instead of staying home and teaching as Aelfric thought he ought.

Eadui has left us a self-portrait in BL, Arundel MS 155, the Eadui Psalter. This was written and illuminated by him for use in his own community of Christ Church. The image in question depicts St Benedict, founder of the order, enthroned with Eadui crouching at his feet. The section of the picture occupied by this scene is fully painted and gilded, whilst the adjacent architectural compartment, or cloister, contains Eadui's brethren who look on as wraith-like tinted drawings. This is probably intended to emphasise the distinction between sacred and earthly spheres. Eadui's prostrate body spans the two zones, but even his bottom which extends into the tinted drawing area is resplendently fully painted and 'sacred', despite his girdle

which is labelled 'the zone of humility'. Despite this, Eadui apparently felt little compunction in seeing and depicting himself as a mediator between heaven and earth. We can also imagine him at the forefront of the conflict which broke out in the Christ Church scriptorium shortly after 1000 when the Archbishop obtained the famous Carolingian Utrecht Psalter on loan as a model (*see* Caroline Minuscule, page 67). The problems of integrating text and image which it addressed so absorbed the team that they soon had the volume disbound to analyse how it was put together. The unorthodox decision was taken to let the artists take the lead in preparing the layout, but the scribes rapidly found that they could not tolerate this, as they were using a different version of the text and a different 'point size' to their model, re-placing the 'Gallicanum' version of the Psalms with the 'Romanum' used at Canterbury and writing in Caroline Minuscule rather than the Rustic Capitals of the Utrecht Psalter. The scribes reclaimed the initiative and the artists soon found their picture-spaces compromised. Eadui, who was part of the team, would probably have been vociferous on the subject, but it would be fascinating to know which function this accomplished artist-scribe viewed as paramount.

Another monastic scribe with a thirst for travel was that of the Ramsey Psalter (BL, Harley MS 2904), thought on liturgical grounds to have been made at Ramsey but now considered a Winchester work of the last quarter of the tenth century, famed as the model for Edward Johnston's Foundational Hand. He too wrote an English Caroline, but one of great breadth and rotundity, reminiscent of the Half-uncial of the Lindisfarne Gospels, which eschewed the slight compression and much of the detailing of Eadui's hand. The trends advocated by Eadui were to prove extremely influential in the English contribution to the development of Protogothic and Gothic book script, but that of the Ramsey Psalter scribe has extended across time to influence modern calligraphy.

The hand of the Ramsey Psalter artist, who is probably also its scribe, is to be found in several books produced in Continental scriptoria. These in-clude the Boulogne Gospels (Boulogne, Bibl. Mun. MS 11), made at St Bertin at the end of the tenth century and illuminated by our master, and a copy of Cicero's Latin translation of the Phaenomena of Aratus (BL, Harley MS 2506). This deals with the constellations and their mythology and was penned in Caroline Minuscule by the monks of Fleury but illustrated with tinted drawings of breathtaking elegance by their English visitor, in homage to the animated drawing style of the ninth-century Reims school which he did much to popularise in England. It is as if he 'scribed for his supper' wherever he stayed, perhaps whilst accompanying a prince of the Church on his travels. This is a far cry from the lack of mobility with which we associate the enclosed monastic regime of the high Middle Ages. The Ramsey master had the opportunity to study the production of Caroline at first hand, but combined it with what he appreciated as the strengths of his indigenous tradition, fusing these influences to produce one of the truly great hands of all times.

Analysing the Script – *English Caroline Minuscule*

This round and open hand with its clearly written letters is the example chosen by Edward Johnston for his Foundational Hand. It is analysed on page 18, and another section is shown here without the lines for analysis so that it is easier to appreciate the beauty of the script.

&uoce psalmi. intubis ducalib;

&uoce tubae corneę

I ubilate inconspectu regisdni

moueatur mare &plenitudo eiu͛

orbis ÷ terrarum: &q habitant ineo

F lumina plaudent manus simul

montes exultabunt a͡cspectu dni

qm uenit iudicare terram

I udicabit orbem ÷ terrarum:

iniustitia &populosinequitate

Psalmus d a

D Hs regnauit irascantur populi

quised &super cherubin

moueatur terra

O ns insion magnus &excelsus

super oms populos

C onfiteantur nominituo magno

English Caroline Minuscule formed the inspiration for Edward Johnston's Foundational hand.
Winchester, late 10th century.
BL, Harley MS 2904, f. 122v.

78

Enlargement from the Ramsey Psalter
BL, Harley MS 2904, f. 118.

Below: The ampersand, *or et*
ligature replaces the letters et
in some words and is a most ele-
gant form.
BL, Harley MS 2904, f. 118.

Referring back to that analysis on page 18 – 19, the *x-height* is between 3·5 and 4 nib widths, with *ascenders* and *descenders* between 6·5 and 7 nib widths. The letter **g** is an exception, descending as it does to about 8 nib widths. The space between the lines – inter-linear space – is 6 nib widths which allows for most of the ascenders and descenders not to clash.

There is an almost consistent *pen nib angle* of 30°, varying only slightly as the pen is lifted from the page, or the hand moves along the line, as with normal handwriting.

The *shape of the letter o* is round, like two overlapping circles, which gives a characteristic oval shape to the counters, or white spaces, of the letters based on the letter **o**, such as **p, d, b** and **q**. This roundness also gives the form to letters which have arches, such as **n, m, h, p, b,** and so on. The arch shape starts high up on the downstroke, close to the upper line for x-height. The arches are round and not asymmetrical. A similar shape is found at the base of letters such as **u, d** and **q**, where the up-curving arch meets the straight downstroke close to the base line for x-height. The curve of the letter **o** is also found at the base of the letters **t** and **l**, although the latter is occasionally truncated by the following letter as at the beginning of the second line in the enlargement above.

Foundational Hand is usually written upright, but the letters in the Ramsey Psalter *slant* forward slightly at angles which range from 0° to the vertical to 4°. A slant of about 2° will produce letters similar to those shown here.

The *stroke sequence* is shown on the exemplar letters.

There are four types of *serifs* shown on the enlargement. Most letters have simple entry and exit strokes, as on letters such as **i, u, m** and **n**. Some of the ascenders have club serifs, probably formed by pushing a flexible quill up and slightly to the left before making the downstroke. These serifs can

English Caroline

Letter height:
4 nib widths;
ascenders and
descenders
7 nib widths

Nib angle: 30°

Letter O form:
Round as in
two overlapping
circles

Slant: 2°

Stroke sequence:
As shown on the
exemplar letters

Speed: Slow

Serifs: Simple en-
try and exit strokes
on some letters,
club, beak and tick
serifs on others

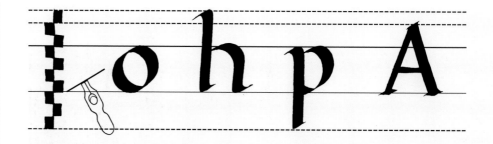

Below: Letters which require particularly careful construction.

*There is a degree of tension at the base of letters **l** and **b,** where the curve is not an angle, but slightly angular. Note the position of the start of the arch on the letters **n, h, m,** etc. To reflect that round letter **o,** these arches start close to the upper line for x-height. If you start the arch too low then not only does it not follow the pattern for the hand, but often becomes asymmetrical in the need to make a wide letter. The letter **g** has a rather idiosyncratic tail, extending to the right more than would be expected. Copy this letter if you choose to be true to the hand, or make the tail sit comfortably under the letter. The first **o**-shape is smaller than the x-height, and is about two-thirds of the width of those lines.*

Below: Roman Capitals to use with English Caroline Minuscule. You may prefer to slant these letters at 2°.

ABCDEFGHIJKLMN
OPQRSTUVWXYZ

Letters which start with a downstroke

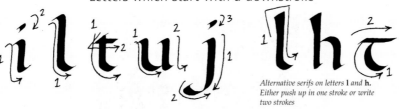

Alternative serifs on letters l and h.
Either push up in one stroke or write
two strokes

Letters which start with a downstroke and then arch

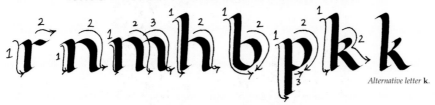

Alternative letter k.

Letters based on the letter o

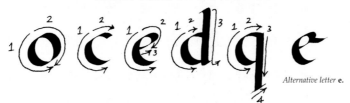

Alternative letter e.

Diagonal letters

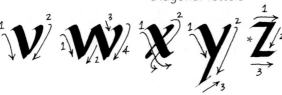

Flatten the nib to
10° for the diagonal
stroke on the letter z.

Alternative letter x.

Letters which do not fit these families

Ampersand

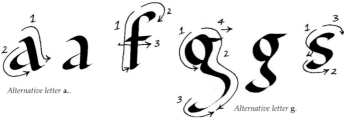

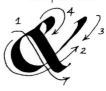

Alternative letter a..

Alternative letter g.

Punctuation

Numerals

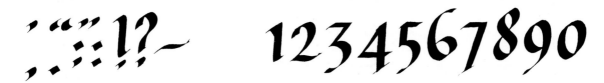

abcdefghijkklmnopqrstuvwxyz

Writing English Caroline Minuscule.

107

hominibuf prauemore &expectatione · quae fuper uenient
uniuerfo orbi · Nam uirtutef caelorum mouebuntur
t tunc uidebunt filium hominif uenientem innube · cum potefta
te magna &maieftate · hif autem fieri incipientibuf · refpicite
&leuate capita ueftra · qm adpropinquat redemptio ueftra ·
Et dixit illif fimilitudinem · Uidete ficulneam &omnef arbo
ref cum producunt iam exfe fructum · fcitif qm prope eft eftaf ·
Ita &uof cum uideritif haec fieri · fcitote qm prope eft regnum
di · Amen dico uobif · quia non preterbit generatio haec · donec
omnia fiant · Caelum &terr tranfibunt · uerba autem
mea non tranfibunt ·

A tendite autem uobif · ne fofte grauentur corda ueftra incra
pula &ebrietate · &curif huiuf uitae · &fuper ueniat in uof
repentina dief illa · Tamquam enim laqueuf fuper ueni &
in omnef qui fedent fuper faciem omnif terrae · Uigilate
itaque omni tempore · oranc uc digni habeamini fugere
ifta omnia quae futura funt &ftare ante filium hominif
Erat autem diebuf docenf in templo · Nocctibuf uero exienf
morabatur in monte qui uocatur oliueti · &omnif populuf
manicabat ad eum in templo audire eum ·

A DPROPINQUABAT AUTEM DIES FESTUS
azimorum qui dicitur pafcha ·
Et quaerebant principef facerdotum &fcribae quomodo eum
interficerent · timebant uero plebem ·
Intrauit autem fatanaf in iudam qui cognominabatur fca
rioth · unum de duodecim ·

Cap: 22:

English Caroline Minuscule by Eadui Basan. Christ Church, Canterbury?, c. 1020
BL, The Grimbald Gospels. Add. MS 34890, f. 107.

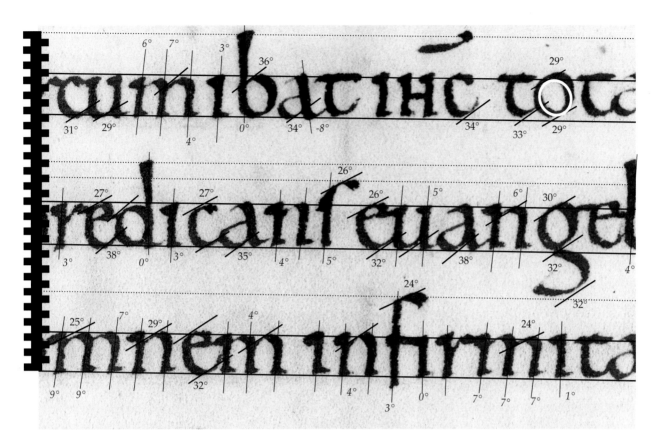

Enlargement for analysis.
The angle for slant is taken against
the vertical and that for pen nib
angle against the horizontal.
BL, The Grimbald Gospels.
Add. MS 34890, f. 14.

be seen on the letter **l** on the enlargement on page 79. The other serif on the ascenders is a beak serif, as seen on the letter **d**. This is formed by making a curved stroke to the right and down before the downstroke. *See* page 19 for a diagram of how this is formed. Descenders on letters such as **p** and **q** have a small tick serif. This could have been formed as the pen was moved from the paper as in the first letter **p** in the enlargement, although the letter **q** shows a more defined stroke.

There are few ligatures joining letters together in this alphabet style, and the letters themselves and the serifs are carefully constructed. The size of the letters and the whole manuscript shows an air of careful construction and it is likely that the *speed* at which they were written was slow.

Analysing the Script – *Compressed English Caroline Minuscule*

The elegant ampersand in the
Grimbald Gospels, written by
Eadui Basan.
BL, The Grimbald Gospels.
Add. MS 34890, f.14.

This hand has a light and delicate touch with many of the characteristics of the letters from the Ramsey Psalter, but the increased x-height and heights of ascenders and descenders, together with a greater interlinear space produce a most elegant and refined alphabet style.

The *x-height* is 5 nib widths, with ascenders and descenders twice the body height at 10 nib widths. The interlinear space of 10 nib widths also means that the descenders of one line do not clash with the ascenders of the line below.

There is a variation in the *pen nib angle* from 24° to 38° in the enlargement shown; an angle of about 30° will produce letters similar to those above. There is also some pen manipulation on some strokes of the curved letters. The terminals at the base of the downstrokes have a distinctive exit stroke which adds emphasis and elegance to the letter. This is shown on letters **l** and **b.**

83

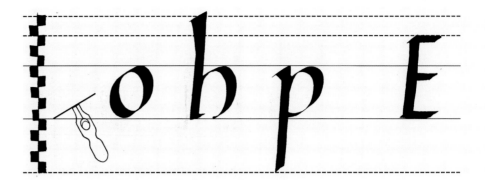

Compressed Caroline

Letter height:
5 nib widths;
ascenders and
descenders 9 –
10 nib widths

Nib angle: 30°

Letter O form:
Forward slanting
oval

Slant: 5°

Stroke sequence:
As shown on the
exemplar letters

Speed: Slow to
moderate

Serifs: Wedge-shaped
entry strokes to
letters without
ascenders, club
serifs to ascenders
and tick serifs as
exit strokes

*Below right: Letters which
require particularly careful
construction.*
*The letter **d** is formed by making
a letter **o** before the downstroke.
This leads to a rather clumsy jux-
taposition of strokes. The letter **e**
has a very flowing base curve,
which you feel the scribe really
enjoyed making. Take the nib fully
round for this stroke, as if making
an **o**. The letter **g,** too, is formed
by making the letter **o** before the
tail, and unusually for this letter
the **o** shape extends from top to
base line for x-height.*

English Car

The *shape of the letter o* is an oval – a slightly compressed circle, and this gives the width to the other letters and the form to most. This lettershape is mirrored also in the arches of letters such as **n, m** and **h,** and in the upward sweep of the curve on the letter **u.**

There is a decided forward movement to the letters as shown by the *slant* which ranges from about 2° in the enlargement to 9°. A slant of 5° is about average and will produce letters similar to those in the example.

The *stroke sequence* is shown on the exemplar letters.

At first sight some of the *serifs* may look like simple entry strokes from a not very sharp quill, but a closer study of the letters **i** at the start of lines 1 and 2 and towards the end of line 3 shows that these are in fact wedge serifs, made by maintaining an angle of 30° and moving the pen slightly downwards and to the right before the main downstroke is made. The ascenders have club serifs, made by moving a light quill upwards and slightly to the left before making the main downstroke.

There are few ligatures to this style of writing, and the serifs are carefully constructed. Although a slight forward slant does indicate a flow and degree of speed to this hand, it is not written quickly, and the *speed* is slow to moderate.

Letters which start with a downstroke

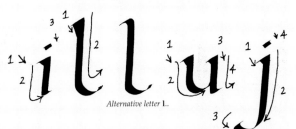

Alternative letter l..

The serif can also be made in two strokes. The first down and to the right, followed by the downstroke.

Letters which start with a downstroke and then arch

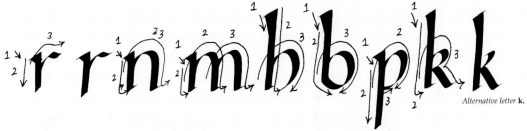

Alternative letter k.

Letters based on the letter o

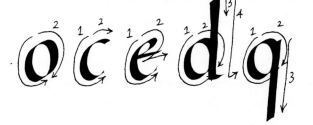

Diagonal letters

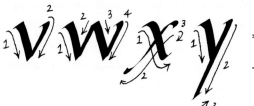

Flatten the nib to 10° for the diagonal stroke.

Letters which do not fit these families

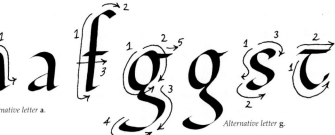

Alternative letter a.

Alternative letter g.

Ampersand

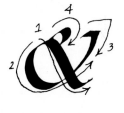

Punctuation

Numerals

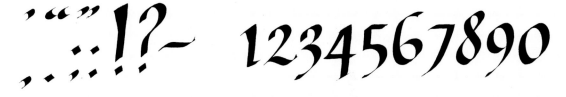

aabcdefghijklmnopqrstuvwxyz

Writing Compressed English Caroline Minuscule.

85

A man's mind quickened with a plan:
subtle and strong-willed, he bound
the foundations with metal rods – a marvel.
Bright were the city halls, many the bath-houses,
lofty all the gables, great the martial clamour,
many a mead-hall was full of delights
until fate the mighty
altered it.

Above: The style of writing in The Ramsey Psalter is strong and dramatic and is suited to texts which reflect this strength. Here an extract from the Anglo-Saxon poem, **The Ruin**, has been written in English Caroline on bold horizontal stripes of red, suggesting the metal rods which bound the foundations.
Below: A subtler and gentler approach using English Compressed Caroline. The delicate style of this hand suits the extract from the Song of Solomon, Chapter 4, verses 13 – 16. These have been written on a wash with the same words written larger. This hints at palimpsests where text was erased from manuscripts (but not always completely) to be used again, and the positioning of the words suggest an enclosed garden.

Thy plants are an orchard
of pomegranates,
with pleasant fruits:
camphire with spikenard,
spikenard and saffron,
calamus and cinnamon,
with all trees of frankincense
myrrh and aloes
with all the chief spices.
A fountain of gardens,
a well of living waters
and streams from Lebanon.
Awake, O north wind;
and come, thou south:
blow upon my garden,
that the spices thereof
may flow out.

Gothic Book Script

The Benedictine scribe, John Whas, from the Sherborne Missal. Sherborne, Dorset, 1400–1407. BL, Add. MS 74236, page 27.

The Sherborne Missal
BL, Add. MS 74236, page 27.

With the rise of the universities from around 1200 and the growing emphasis upon towns as manufacturing centres, lay people became increasingly involved with the production and consumption of books. Scribes, illuminators and parchmenters, both male and female, would convene together to live in their respective streets and quarters in major cities such as Paris, Bologna and Oxford. Sometimes they might form workshops or ateliers in which a number of people worked under a master, but generally their working lives were regulated by professional stationers (*libraires* or *cartolai*) who received and farmed out commissions. They also controlled 'official' editions of texts which had been authorised by the university authorities and which they rented out to scribes for copying as piece-work (the *pecia* system). Such copies are identified by the pecia marks which they sometimes still retain in their margins, usually in the form of a **p** with a suprascript **a** followed by a number, indicating which section was being copied. The stationers would sub-contract work to their favoured craftspeople and were responsible for arranging their work into saleable units, sometimes on commission and sometimes as stock. The various systems of marking-up work with instructions to assist other members of the production team so that it could be assembled for binding proliferated from this time, including more systematic ways of identifying the sequence of quires (quire numeration) or of leaves within a quire (quire signatures). So too did the practice of frame-ruling for texts, in a more 'mechanical' fashion, perhaps with the aid of templates or pricking wheels.

In this environment scribes had to hustle and advertise their skills, developing a meticulous pricing system for every component. A hierarchy of scripts prevailed, as it had in the commercial publishing houses of ancient Rome, in which time was money. Even Gothic *textualis* (Gothic Book Script or black-letter script) had four grades, priced according to the degree of effort expended, notably upon the treatment of minims. Script with minims that terminated parallel to the base line was the most expensive and was known as *textualis prescissa*. That with consistently applied wedges to the feet

Gothic textualis prescissa, *from the Luttrell Psalter, made for Sir Geoffrey Luttrell of Irnham, Lincs., during the 1330s.* BL, Add. MS 42130, f. 208.

of minims was known as *textualis quadrata*. That with sporadically applied foot wedges was *textualis semi-quadrata* and that without feet but with a simple up-turn of the pen was *textualis rotunda*. In addition to these variants of Gothic Book Script, thinner Gothic cursives (*Cursiva anglicana* in England and 'secretary' in France) also became popular for cheaper book production during the late thirteenth and fourteenth centuries. 'Point size' also increasingly became a consideration as layers of texts and commentaries were wrapped round one another on the page in glossed biblical and legal works designed for study. Professional chancery scribes and urban notaries likewise became responsible for document production, and heralds for illuminated pedigrees and rolls of arms.

Sometimes work travelled during production. The Smithfield Decretals (BL, Royal MS 10.E.iv), a text of canon law, was written in the great centre of legal studies, the university town of Bologna around 1330. Its preface indicates that it was intended for use by the University of Paris, but during production it moved to England where it was illuminated with some of the liveliest *bas-de-page* scenes in Gothic art and was subsequently used at the Priory of St Bartholomew, Smithfield, in London. Projects and personnel could be highly mobile and influences travelled fast.

Monastic scribes did not, of course, pack up their quills and call it a day. Work in the scriptorium remained part of the *opus dei* ('work for God'). Their work in the production of sacred texts and theological library books was increasingly supplemented by more mobile clerics, such as the friars and those in minor orders, who bridged the worlds of the cloister and the town.

Sometimes craftspeople from both orbits would work together, with lay artists assisting in monastic production, as they probably had done on occasion even earlier in the Middle Ages. When noble patrons such as Geoffrey, Lord Luttrell, who commissioned the Luttrell Psalter in Lincolnshire in the 1330s, ordered books to be made as acts of piety and to record their wealth and power for posterity, they frequently involved their chaplains and their favourite monasteries in the work.

The Sherborne Missal (BL, Add. MS 74236), the largest, most complete and ostentatious English servicebook to have survived the Reformation intact, is an interesting example of collaboration. It was commissioned between 1400–1407 by Robert Bruyning, Abbot of Sherborne, and Richard Mitford, Bishop of Salisbury, for the Benedictine abbey at Sherborne. The master scribe was a Benedictine named John Whas, probably a member of the Sherborne community, who records in a colophon that the work was so onerous that he had to rise early each morning and that his body was much wasted as a result. The major illuminator was a Dominican, John Siferwas, who had been a member of the friary at Guildford and who had undertaken some commissions for aristocratic patrons in the courtly 'International Gothic' style. One such work, the Lovell Lectionary (BL, Harley MS 7026), had been presented by John, Lord Lovell, to Salisbury Cathedral, perhaps bringing Siferwas to the attention of the Bishop who may have recommended him for work on the Missal. Spiritual humility and anonymity were not major considerations in this enterprise. Depictions of the 'team', both patrons and craftsmen, abound in what remains one of the greatest icons of corporate sponsorship ever made.

Analysing the Script

At first sight this dense black script appears to be so controlled and rigid that there seems little allowance for any personal interpretation. The consistency of the downstrokes and the compact nature of the script reinforces here the impression of a picket fence. However, a closer examination shows that the scribe has been able to make his or her own mark. Using the corner of the nib there are hairline extensions to many letters – the left-hand fork fishtail serif on the ascenders on letters **l, b** and **h** on the enlargement and on the last stroke of the letters **s, e** and **r.** There is even a hairline flourish on the colon. It is obvious from this example from the Bedford Hours why it became necessary to put a mark over the letter **i** so that letters were distinguished and words were easier to read. Here that mark is the lightest hairline but written in a very personal and distinctive way. However, the difficulty of writing this alphabet with almost all letters formed by a starting diamond followed by a downstroke which ends in a diamond is shown in this extract where concentration has been lost and the scribe has written a different letter **a** to the usual one. By simply making a hairline horizontal stroke a mistake has been rectified!

The *x-height* is just over five nib widths, with ascenders and descenders at 6·5 or 7 nib widths; the letter **d** being less high. Interlinear space is only 4 nib widths, which just about allows for no clashing of ascenders and descenders between the lines but does give a very dense impression on the page. Reading a lot of Gothic Book Script as compact as this with lines as close together as on the enlargement must have been very challenging.

The *nib angle* is not as consistent as it appears, ranging from 34° to 48° in the enlargement. An angle of about 45° will give letters looking like these.

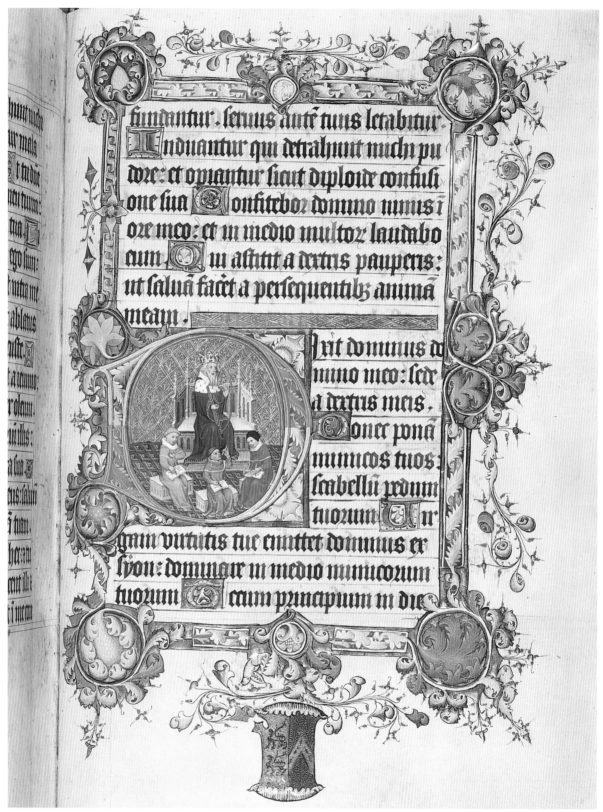

Gothic textualis quadrata *from the Bedford Hours, made in Paris to celebrate the marriage of John, Duke of Bedford, English Regent of France, and Anne of Burgundy – a treaty designed to keep France under English rule following the Battle of Agincourt.*
BL, Add. MS 42131, f. 183.

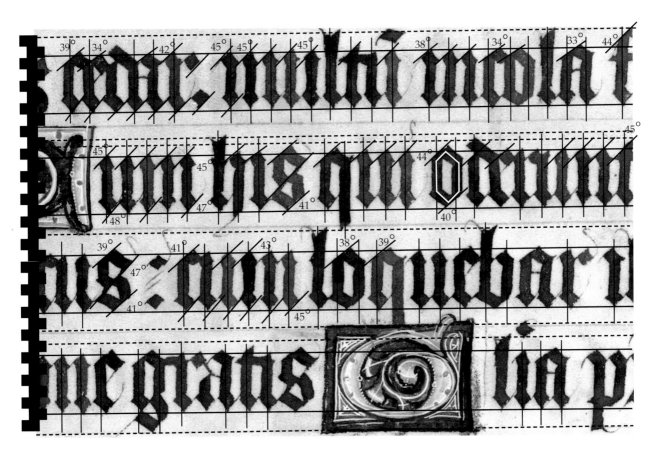

The Bedford Hours. Enlargement.
The upright nature to the letters
is so consistent that measurements
of 0° have not been given. The
pen nib angle is taken in degrees
from the horizontal. Notice the
wonderfully exuberant hairline
flicks and ticks on the strokes
despite the rigid nature of the
alphabet style.
BL, Add. MS 42131, f. 25.

*Below right: Letters requiring
particularly careful construction.*
*Most letters can be constructed
with a maintained pen nib angle
of 45°, however the fishtail serifs
at the start of the downstroke on
ascenders are made by moving the
nib down from the right, and, after
finishing the stroke, pressing the
nib down within the downstroke
to release a little ink. The left-hand
corner of the nib is used to pull this
ink into the shape required. This is
similar to the letter **a**. The downstroke
is made, followed by the lower bowl.
Then the nib is pressed within the
downstroke to release ink and this
is pulled round to make the upper
bowl by the left hand corner of the
nib. Again the left-hand corner of
the nib is used for the fishtail ending
on the letter **p**.*

The *shape of the letter o* is a compressed angular rectangle, with no curves and this gives the shape for almost all the other letters.

At 0° to the vertical the *slant* is rigidly upright. The *stroke sequence* follows the letter construction and is shown on the exemplar letters.

Most letters start with a diamond shape, which could be considered to be either a *serif* or a starting stroke. Ascenders, however, have a characteristic fishtail start. This is made by starting the downstroke with a curve coming from the right. When the stroke has been made, press the nib down within the downstroke to release some ink and simply pull this wet ink up with the left hand corner of the nib to make the left part of the fishtail and the hairline extension, if you wish. In the enlargement the scribe has also taken this wet ink to make a horizontal finish between the two spikes of the serif. The less marked fishtail at the base of the letter **p** is constructed in the same way, and the left hand corner of the nib is also used to pull a hairline of wet ink round to make the bowl on the letter **a**.

Because of the number of pen lifts required to construct these letters the *speed* of writing is slow, however within this it is possible to build up considerable rhythm.

Gothic

Letter height:
5 nib widths;
ascenders &
descenders 6·5
nib widths

Nib angle: 45°,
with the corner
of the nib used
for some strokes

Letter O form:
Angular

Slant: Upright

Stroke sequence:
As shown on the
exemplar letters

Speed: Slow

Serifs: Starting
diamonds with
some fishtail serifs

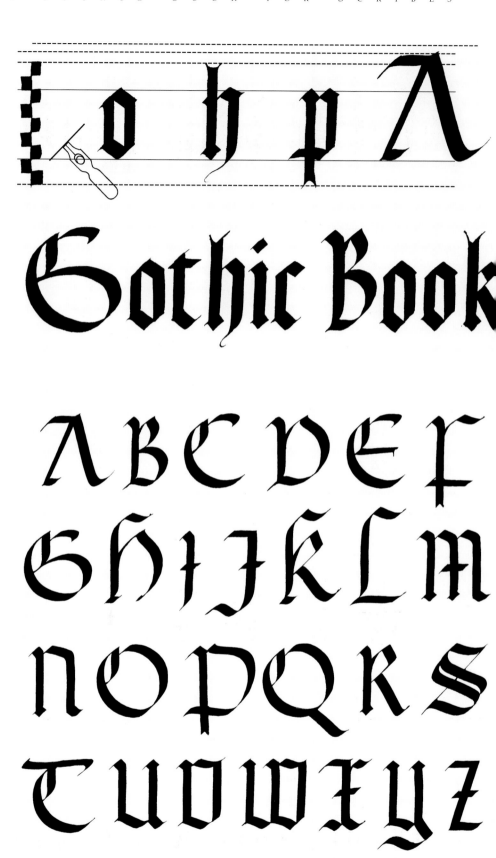

*Capitals to use with Gothic Book
Script.*

Letters which start with a downstroke

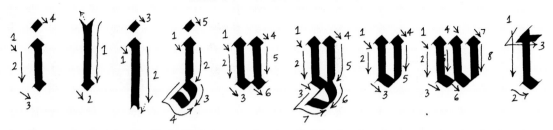

Letters which start with a downstroke and then 'arch'

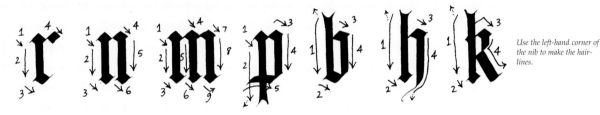

Use the left-hand corner of the nib to make the hair-lines.

Letters based on the letter o

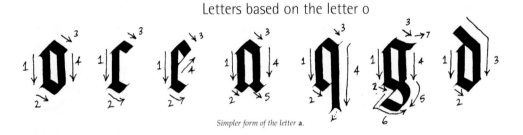

*Simpler form of the letter **a**.*

Letters which do not fit these families

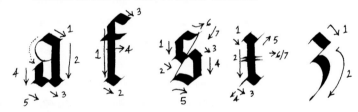

Ampersand

Punctuation marks

Numerals

aabcdefghijjklmnopqrstuvwtyz

Writing Gothic Book Script.

Gothic Book Script was used in many German publications until the 1930s, and it seems to have an association with the German language. This rendition of lines by Goethe from Wilhelm Meisters Lehrjahre – Know you the land where the lemon-trees bloom? In dark foliage the gold oranges glow; a soft wind hovers from the sky, the myrtle is still and the laurel stands tall – do you know it well? There, there, I would go, O my beloved, with thee! *– reinforces that connection, but the orange and green colours of the paint also reflect the words, and somehow soften the dense black letter nature of the alphabet style.*

94

Bâtarde

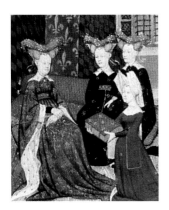

The author-publisher Christine de Pisan presents her work to Queen Isabeau of France, from her own 'edition' of her Collected Works, *Paris, c. 1410–15.*
BL, Harley MS 4431, f.3.

The hierarchy of scripts used in the Gothic system, from *textualis* down to cursive, began infecting or influencing one another from the late thirteenth century onwards. By the late fourteenth century a number of hybrid or 'bastard' scripts had emerged as the progeny of this mixed parentage and these supplanted Gothic *textualis* in writing any but the most conservative or formal of works. The most high-grade of these was Bâtarde, or *lettre bourguignonne*, a fusion of *textualis* and French secretary hands. It takes its name from its association with the high-level patronage of the Burgundian court of the southern Netherlands during the fifteenth and early sixteenth centuries. At this period some of the finest books were made in Ghent and Bruges, often for courtly patrons, ranging from the books of hours (essentially a condensed form of the monastic divine office) used in their private devotions to luxurious copies of secular romances, such as the *Roman de la Rose*.

A leading exponent of Bâtarde was David Aubert, scribe to Philip the Good, Duke of Burgundy, during the later fifteenth century (*see* p. 98). Such courtier scribes frequented the corridors of power and were well acquainted with the need to enhance the stylistic, literary and political pretensions of their patrons. Script had to be as fashionable and stylish (and sometimes as

A later court hand, from William Teshe Penmanship, *1580.*
BL, Sloane MS 1832, f. 22.

A Bastard Secretary Hand. The author-publisher Christine de Pisan at work,
from her own 'edition' of her Collected Works, *Paris, c. 1410–15.*
BL, Harley MS 4431, f.4.

exaggerated) as the current court dress. For less ostentatious occasions a
slightly less formal fashion might prevail, such as bastard secretary or its
English counterpart, bastard *anglicana*, and for more run-of-the-mill items
the plain cursives, secretary or *anglicana*, would suffice. So scribes wore
'different hats' for different occasions, both literally and metaphorically.

Women might also participate in this world, if less frequently, following
the example of a remarkable lady, Christine de Pisan (1364–1430). She was
a courtier in Paris during the early fifteenth century. Her scholarly Italian
father had been recruited by the King of France and had ensured that his
daughter received an excellent education. Having been left a young wid-
owed mother when her beloved husband and father were both carried off
by an epidemic, Christine decided not to adopt the conventional sol-
utions of remarrying or entering a convent, but took the unprecedented
step of trying to earn her living by her pen. Her early outpourings of grief
in the form of moving love poetry gave way to manuals on how to survive
socially and politically in high places and allegorical attacks on a misogynistic
male hierarchy. She was aided in this by the patronage of Queen Isabeau of
France and established her own 'desktop publishing' enterprise, assembling

and leading teams of artists and scribes herself to produce elegant works penned in Bastard Secretary script. One two-volume copy of her collected works (BL, Harley MS 4431) is particularly sumptuous and is probably that designed for presentation to her queen. One miniature depicts Christine handing the work to Isabeau before an approving audience of ladies of the royal bedchamber.

During the sixteenth century courtier-scribes had to reinvent themselves yet again as 'Renaissance men', exhibiting their mastery of the plethora of medieval and Renaissance hands alongside their skills as linguists, diplomats, poets, scholars, musicians and dancers. The court of Elizabeth I was a magnet to the aspiring courtier of accomplishment and could offer the sought-after means of advancement (or penury incurred in the attempt). Their repertoire had to embrace all of the scripts of the late Middle Ages, those of the Humanists and a number of exotic scripts, such as a 'fractured' hand with gaps in the letter-strokes, producing an effect rather as if a computer printer cassette was running out, or prickly foliate letter-forms. One can almost sense the scribe's sharp intake of breath as a prospective client paused over one of these more 'gimmicky' scripts. The New Year's gift lists abound with the calligraphic offerings of figures such as Will Teshe (*see* p. 95), their exuberant artistry clamouring to be noticed amongst the dazzling trappings which surrounded the Renaissance 'prince'.

Analysing the Script

Bâtarde is an elegant and graceful script, which has an almost deceptive ease of writing. It is also a hand which was adapted by writers for their own use, and so there are variations. The one selected for enlargement is one of the most consistent, and certainly one of the most beautiful.

The *x-height* is just over three nib widths, with *ascenders* and *descenders* of five nib widths. However, the long **s** and **f** do sometimes extend beyond this, and although the tail of the letter **g** is written tightly against the base line for x-height, its last downward curve to the left extends a full nib width further. The space between x-height lines – the interlinear space – is five nib widths. The look on the page is of a greater distance than this, but as the x-height and heights of ascenders and descenders are low there is an allowance between the lines and no collisions of letters.

There is some manipulation of the pen and changes of *nib angle* to achieve this writing style, but an angle of about 40° to the horizontal will produce letters similar to those in the example. To achieve the pointed finish to the letters **f** and the long **s** the pen nib is turned gradually when writing so that it finishes the stroke at 90° to the horizontal, almost completely vertical.

The *shape of the letter o* is a pointed oval.

The *slant* of letters varies from 10° for the long **s** and **f** to 6° for some strokes and the letter **p,** and a slope of between 0° and 4° for other letters and strokes. A consistent slant of about 3° has been chosen as the average, with a greater slant of 10° for the long **s** and **f.**

The *stroke sequence* is easy and flowing, although there is evidence of using the corner of the nib for hairline decorations. The long **s** and **f** are made with two downwards strokes of the pen. Although a flexible quill can be manipulated to make the swelling in the middle of the stroke, there is evidence in the manuscript to suggest that this was in fact made with two strokes, with a pen lift in between.

Although the hand is elegant and graceful, it gives the impression of a

Vita Christi, etc. 'penned ' in a Bâtarde script and possibly compiled by the Burgundian court scribe, David Aubert, who is depicted at work and presenting his labours to his patron, Philip the Good, Duke of Burgundy. Ghent, 1479.
BL, Royal MS 16. G. iii, f. 8.

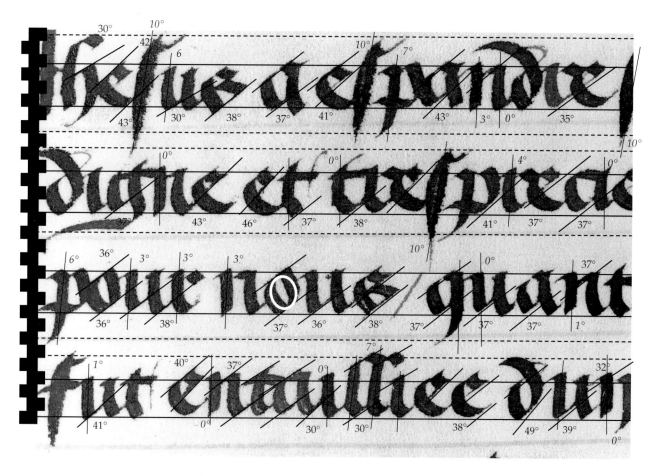

Bâtarde. Enlargement for letter analysis. Angle of slant is taken as degrees from the vertical, and that for pen nib angle as degrees from the horizontal.
BL, Royal MS 16. G. iii, f. 39v.

degree of *speed* in its formation. There are many joins between letters as one flows naturally from the other. However, there are also delicate uses of hairlines, as on the letter **d** and **t**, indicating that there were points where the scribe stopped the flow of writing and enjoyed the decoration.

In the main the *serifs* are simple starting and ending strokes. Some letters, though, start with a carefully constructed diamond shape.

Right: *Nib angle, x-height, heights of ascenders, descenders and capitals for Bâtarde.*

Bâtarde

Letter height:
3 nib widths;
ascenders &
descenders
5 nib widths

Nib angle: 40°,
with a steepening
of the nib for the
long **s** and **f.**

Letter O form:
pointed oval

Slant: 3°, with a
slant of 10° for
the long **s** and **f**

Stroke sequence:
As shown on the
exemplar letters

Speed: Moderate

Serifs: Simple start-
ing and ending
strokes.

Above: Letters which require particularly careful construction.
The letter **d** is formed from three strokes. The first and second construct the body of the letter, although the second stroke curving down to the right needs careful placing – the letter should not look as if it is falling over. Press the nib down within that stroke to release some ink and then pull out the hairline stroke with the left-hand corner of the nib, either from the first stroke or to join the first stroke. The letter **f** and the long **s** could have been made with one downstroke using a flexible quill, by pressing hard as the nib is turned to make the narrow, pointed terminal. With a metal nib, though, you will need to make two strokes to achieve the central swelling of the letter. Make the first stroke with the nib at 40°, and gradually turn the nib so that is steepens as the stroke is made. Lift the pen and make a separate stroke for the slight swelling in the middle of the letter. The long strokes of the letters **g** and **y** are made from the right to the left. With the ink still wet, use the left-hand corner of the nib to extend the hairline down-wards.

Below: Capitals to use with Bâtarde

λ β ε δ ε f ϭ

ɧ ɟ ɟ ƙ ʟ ɱ ɳ

ο ρ ϙ ƙ ʂ ƭ

ʋ ʋ ʍ ƥ ʏ ʑ

Letters which start with a downstroke

Letters which start with a downstroke and then arch

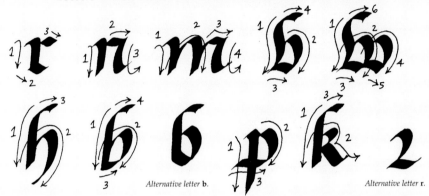

Alternative letter b. *Alternative letter r.*

Letters based on the letter o Letters based on the letter a

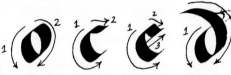 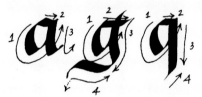

Letters which do not fit these families Tironian et symbol

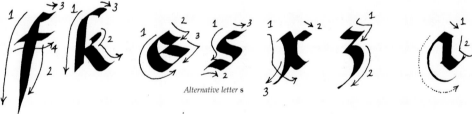

Alternative letter s

Punctuation Numerals

; . : ; ! ? - 1 2 3 4 5 6 7 8 9 0

a b b c d e f g h i j k l m n o p q r s ſ e t u b w x y z

Writing Bâtarde.

la place

retentissante de cris, sentait des fleurs

qui bordaient son pave, roses, jasmins,

œillets, narcissus et tubéreuses, espacés

inégalement par des verdures humides,

de l'herbe-au-chat et du mouton pour

les oiseaux: la fontaine, au milieu, gar-

gouillait, et sous de larges parapluies,

parmi des cantaloups s'étageant en

pyramides, des marchandes, nu-tête

tournaient dans du papier des bouqu-

ets de violettes.

*This writing style has many links with France, David Aubert, scribe to Philip the Good, Duke of Bur-
gundy, being a leading exponent. It seems natural, therefore to show how this hand looks by using an
extract from the great French author Gustave Flaubert in his novel* Madame Bovary. *The extract
describes a market*: the square echoing with voices, was scented with flowers which bordered
the flagstones – roses, jasmine, pinks, narcissi and tuberoses, interspersed with moist greenery,
catmint and chickweed; the fountain in the centre was gurgling, and under large umbrellas,
amongst melons arranged in pyramids, the bare-headed stall-holders were wrapping up
bunches of violets in paper.

Italian Rotunda

St Gregory as a scribe, from the Sforza Hours, Milan, 1490s. BL, Add. MS 34294, f. 196v.

Throughout the Middle Ages Italy generally reflected the trends in script witnessed elsewhere in Europe, but it clung persistently to its Roman legacy of high-grade formal scripts. This conservatism manifested itself primarily in an adherence to the principles of breadth and rotundity of aspect. Caroline Minuscule was introduced around 800 and formed the basis of the later Gothic Book Script, but without the compression and angularity seen elsewhere in Europe. Only in the major production centre of the university town of Bologna, which was more keyed in to European mainstream tendencies through the university network, were such tendencies hinted at. Bolognese Script features some biting of bows as a sign of incipient compression and is not as rounded as the usual Italian Rotunda script. Such compressed script is known as Italian Bolognese Gothic Rotunda Bononiensis Book Script *(littera Gothica Textualis)*. An example of a Bolognese product is the Smithfield Decretals (BL, Royal MS 10. E. iv), reproduced on page 105. It was written in Bologna in the 1330s probably for Paris University use, but travelled to England, where it was illuminated (*see* Gothic Book Script, page 87). The degree of compression and squareness of aspect is still much less than that common to northern European *Textualis*. The rounded version favoured throughout most of Italy (other than the southern duchy of Benevento which retained its own post-Roman minuscule) is known as Italian Rotunda, or Italian Gothic liturgical hand. It continued in use for servicebooks and the like until the seventeenth century. It is often writ large to enable whole choirs to read it at a distance and it is particularly formal and stately. It would have been employed where appropriate by cleric and lay scribe alike.

The example illustrated here is from BL, Add. MS 28025, a manual for ecclesiastical use, probably copied in Ferrara around 1400. In addition to the characteristic breadth and rotundity, note the conservative use of an uncrossed Tironian symbol, resembling a **7**, for **et**. Tiro was the freedman secretary of Cicero and in the first century BC invented a shorthand system (Tironian notes) which were to prove highly influential during the early

Italian Rotunda in the Sforza Hours. Milan, c. 1490.
BL, Add. MS 34294, f. 255.

Middle Ages, with some persistent features such as this surviving in places throughout the medieval period. Note also the particularly fine pen-flourishing of minor initials which is a feature of Italian Gothic script, although other distinctive forms of flourishing also occur in northern European work.

Even following the introduction of the fashionable Humanistic scripts, *Rotunda* was still commissioned by the Italian nobility of the Renaissance for their devotional books. The Sforza Hours (BL, Add. MS 34294) is one such commission. It was ordered around 1490 by Bona Sforza, Duchess of Milan and head of one of the most glittering Renaissance courts, of the court painter Giovan Pietro Birago. The scribe who worked with him produced an elegant, legible *Rotunda* which processes leisurely across the page, leaving as few words behind as is necessary. In its conservatism it would be

An Italian Bolognese Gothic Book Script, and St.Dunstan depicted as an artist, from the Smithfield Decretals, a book of Canon Law, written in Italy (Bologna) and illuminated in England, c. 1330. BL, Royal MS 10. E. iv, f. 248.

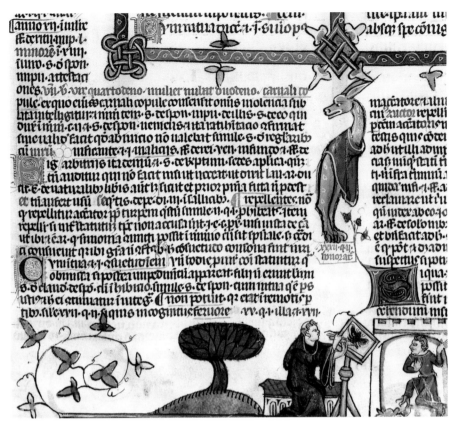

Below: The prescissa terminals can be constructed either by turning the nib whilst writing the stroke, as shown in the upper illustration, or by using the left-hand corner of the nib to outline the base and fill in the stroke, shown in the lower illustration. The latter is more in evidence in manuscripts.

worthy of the most reactionary churchman, but in the age of the Medici the distinction between prelate and prince was often scarcely observed. Such was the prestige of the Sforza commission that the work was stolen whilst in progress by Fra Johanne Jacopo, a Milanese friar, leading to a frantic chase around Italy. The portion which was stolen was valued by Birago at 500 ducats, five times that placed by Leonardo on his *Virgin of the Rocks*. The incomplete book was sent, around 1517–1520, for completion to the Netherlands by the artist Gerard Horenbout, with a third of its 348 leaves being replacements supplied in a competent (if somewhat shaky) version of the original script – a testimony to the close links between the Italian Renaissance and its northern counterpart.

Analysing the Script

Italian *Rotunda* is one of the most impressive alphabet styles. These glorious letters almost sing out from the page, and coincidentally, were often used in choir books – the large letters, careful construction and clear script allowing the pages to be seen and words read by the whole choir from some distance. Because of this use many existing manuscripts of Italian *Rotunda* also include the ruled lines of a music stave and musical notes. The letters are strong and can stand up well to the elaborate decoration and richly coloured and gilded miniatures and the decorated letters which were often incorporated into the manuscripts.

The letters are quite chunky, with an *x-height* of 4 nib widths. *Ascenders* are about two nib widths in addition – 6 in all, and *descenders* a little longer at 6·5 – 7 nib widths in all.

The *pen nib angle* does not vary very much, ranging in the enlargement

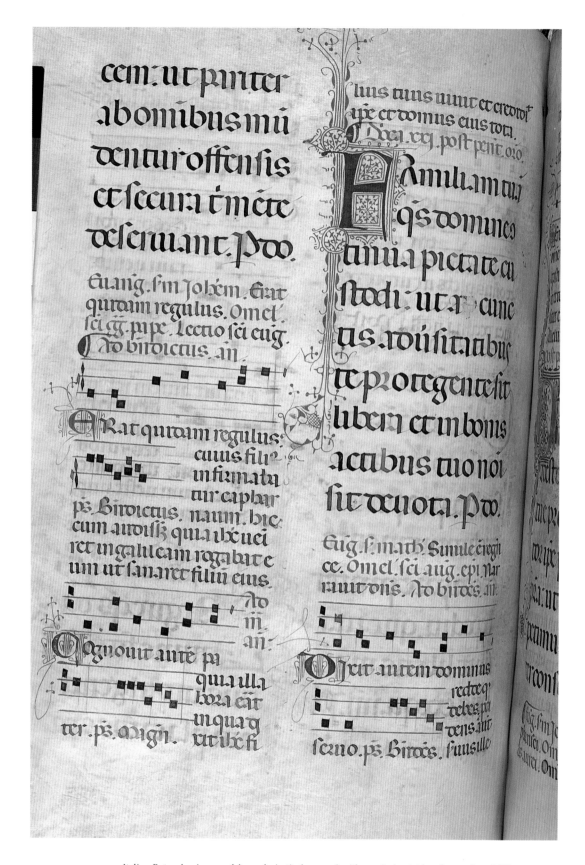

Italian Rotunda. A manual for ecclesiastical use and with musical notation. Ferrara?, c. 1400.
BL, Add. MS 28025, f. 137v.

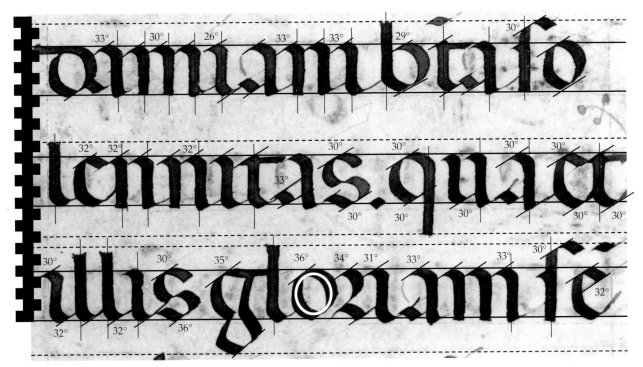

Enlargement of Italian Rotunda for analysis. A manual for ecclesiastical use and with musical notation. Ferrara?, c. 1400. BL, Add. MS 28025, f. 85v.

Below: Capitals to use with Italian Rotunda.

from 26° to 36°; a nib held at 30° to the horizontal will produce letters similar to those shown. An interesting, and distinctive, feature in many examples of Italian *Rotunda* is the downstrokes which terminate as a horizontal line. It is obvious that maintaining a nib angle of 30° will not produce this shape. There are two ways in which this clipped, or prescissa, flat terminal can be produced. The first is that the pen nib is gradually turned from 0° to 30° and back to 0° as the stroke is written. This requires some degree of care and precision, and it is not always easy to maintain that distinctly horizontal terminal. The second way, which is the preferred method

A B C D E F G H I
J K L M N O P Q R
S T U V W X Y Z

Rotunda

Letter height:
4 nib widths;
ascenders 6 nib
widths and
descenders 7

Nib angle: 30°,
with corner of the
nib used for the
terminal of some
downstrokes

Letter O form:
Angular round

Slant: Upright

Stroke sequence:
As shown on the
exemplar letters

Speed: Slow

Serifs: Most hook
serifs with some
prescissa

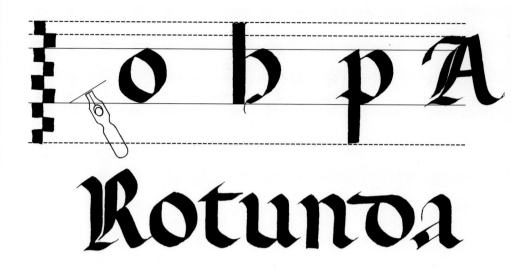

Rotunda

of most of the scribes writing the manuscripts I have studied (note the first and second downstrokes of the letter **m** on the third line of the enlargement for analysis for example), is to maintain the angle of 30° for the whole of the downstroke. Then use the left-hand corner of the nib to carry wet ink from the ends of the stroke as a fine line to finish the stroke horizontally, and also to fill in the remaining white space of the paper or vellum. This is shown on page 105. If writing the fine line is a problem, press the nib down within the thick stroke just written. This will release some ink which can then be pulled into place by the left-hand corner of the pen nib. It is possible to maintain quite a rhythm of writing when making these prescissa terminals, and this action is not so interrupting as may at first be thought.

The *shape of the letter o* is an interesting slightly squared circle, giving the characteristic lemon-shaped counter, or white space. This gives the guide to the remaining round letters, such as **e, c** and **d**. However some of the letters which usually take their shape from the letter **o**, such as **p** and **b** are more rounded. The arches do not always quite fit the letter **o** construction, as they are generally more rounded and less angular or cornered.

The *slant* is very upright with strokes consistently at 0° to the vertical.

The *stroke sequence* is shown on the exemplar letters.

This is a very controlled hand, written at quite a measured and steady *speed.* This is reflected in the *serifs*, which do not appear as such on the minims where the endings are prescissa, or are controlled entry and exit strokes as on the letter **i**, the last stroke of the **m** and **n,** or the slight extension as a hairline to the letters **c** and **e** – although these are so minor that they could hardly be termed serifs.

Below right:
Letters which require particularly careful construction. The letter **a** *is formed similarly to the letters* **a** *in Caroline and English Caroline, however, the fine hairline curved stroke is made with the left hand corner of the nib pulling the wet ink down into the letter. The rather unusual looking letter* **g** *is not difficult to construct if you follow the direction strokes, but look carefully at the counter – white space – within the letter to ensure that you have the correct letter-shape. There is an interesting kink within the letter* **s** *which is formed by slightly lifting the nib from the writing surface and moving it a little to the right and up.*

108

Letters which start with a downstroke

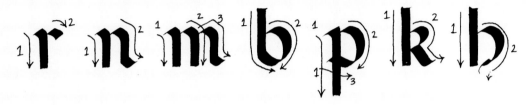

*The letter **y** can be based on the letter **u** as here, or **v**, see below.*

Letters which start with a downstroke and then arch

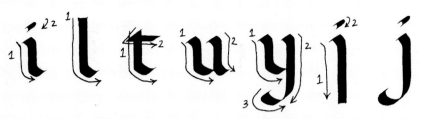

Letters which start with a stroke to the left

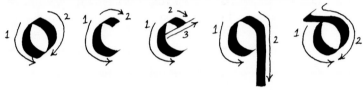

Diagonal letters

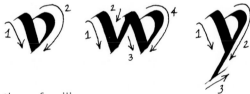

Letters which do not fit these families

Tironian et symbol

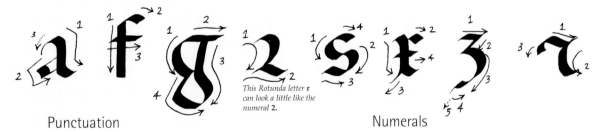

*This Rotunda letter **r** can look a little like the numeral **2**.*

Punctuation

Numerals

Writing Italian Rotunda.

Italian Rotunda is a very strong writing style with much character. The well-known extract from Canto III of The Divine Comedy *by Dante lends itself to a strong interpretation. Here the entrance to the woeful city is indicated as a lighter area within a black mass, and the words themselves are leading into that opening. The translation is:* Through me the way into the woeful city, Through me the way to the eternal pain, Through me the way among the lost people. Justice moved my maker on high, Divine power made me and supreme wisdom and primal love; Before me nothing was created but eternal things and I endure eternally. Abandon all hope, you who enter here.

Humanistic Scripts

The Humanistic system of scripts is generally considered to have taken shape in Florence just before 1400. It consists of the upright Humanistic Book Script and its slanted Cursive, or Italic, versions. In its early stages it was intimately associated with the work of a number of scholar-scribes – the Humanists – who set about producing and publishing their own texts, or editions of classical texts, as part of a renaissance of learning and culture. This is often thought to have been politically as well as culturally motivated and to have represented an attempt to free themselves from the theocratic and imperial Germanic yoke of the Gothic or medieval period, with the aid of a conscious revival of the former glory of the Roman past. The first major scholar to experiment with such a philosophy and to extend it into book production was Petrarch (1304–1374) who began the process of distilling essentially Caroline letter-forms from their Gothic descendants. Caroline Minuscule, as written in northern Italy during the twelfth century, was the principal model, along with its uncoloured foliate interlace which was to inspire the distinctive humanistic white-vine ornament. It is ironic that Charlemagne, the fount of Germanic imperialism, should similarly have encouraged reference to the Roman past as an adjunct to his imperial ambitions, and in so doing have become both model and adversary for the Humanists.

Petrarch's experiments, which are termed 'Semigothic' were carried further during the early fifteenth century by figures such as Poggio Bracciolini (1380–1459), Niccolò Niccoli (c. 1364/5–1437) and Collucio Salutati (1331–1406). Poggio became one of the foremost practitioners of a fully formed Humanistic Book Script (*littera humanistica textualis, littera antiqua* or *lettera antica*) which he was using by 1402. This is essentially a Caroline with a settled stylistic canon and some tendency to apply horizontal feet to minims. It favours Caroline ligatures such as '**ct**' and '**st**' and the ampersand for '**et**'. Subsequent masters of this script included Marcus de Cribellariis of Vicenza (whom Edward Johnston was keen on illustrating) with his 'flying pen' (*calamo volanti*) which he mentions in his colophon, Matteo Contugi, Pierantonio Sallando and Rodolpho Brancalupo, who worked in Naples for

Humanistic Book Script, as written by Rodolpho Brancalupo for Ferdinand of Aragon, in a copy of St Augustine's Commentary on the Psalms. *Naples, 1478.*
BL, MS Add. 14779. f. 71v.

Ferdinand of Aragon (*see* above).

One of the best known and most prolific Humanistic scribes was Bartolommeo Sanvito (1435–?1518), a Paduan who excelled in the production of all the Humanistic hands and who had made an antiquarian study of ancient Roman inscriptions. This antiquarian interest was engendered by a North Italian circle of Humanists, centred on Felice Feliciano and Cyriacus of Ancona, during the mid-fifteenth century. Such studies inspired Sanvito's use of antique monuments and classicizing decorations as surrounds to his script, and the elegant lines of multi-coloured Square Capitals which distinguish the display openings of his work. One of his finest pieces, the King's Virgil (BL, King's MS 24), is illustrated here (*see* pages 26, 114). The prevalence of lambs in the ornament (*agnelli* is the Italian for lambs), along with heraldic evidence and the fact that a passage relating to Mantua is written in gold, indicate that it was made for a prelate of the Agneli family of Mantua. Sanvito often appears to have worked with artists working in the Veneto-Paduan style associated with the circle of Mantegna and Bellini, and probably especially one by the name of Lauro Padovano. He was also an illuminator in his own right, however, with two volumes which he presented to the college at Monselice towards the end of his life containing an inscription stating that they were written and illuminated by the scribe at his own

Rubi cymas in uino austero ad ter
& ex eo more tenes, & ipsa folia r
Nomen herbe millefolium.
A grecis dr mirion fyllon. alij am
chillofyllon. alij chrysiten. Galli r
alij vigentiam. Dacy diodela. Ita
alij militaris achillion. alij super

expense. Sadly, in later life Sanvito complained in his journal of the scribe's enemy, arthritis, the effects of which can be charted through his later works. The picture which emerges of Sanvito, from his œuvre and his relations with contemporaries, is of a Renaissance gentleman of good social standing, an antiquary and a supremely gifted artist-scribe.

From innovative Humanistic centres such as Florence and Rome the Humanistic scripts began to spread throughout Europe. Their dissemination was hastened from the 1440s onwards by the eager endeavours of the stationers/booksellers known as *cartolai*, such as Vespasiano da Bisticci who included many eminent Englishmen among his clients. Long-lived success was finally assured when Humanistic Book Script was used as the inspiration for the 'Roman' typeface, in its Veneto/Roman form.

The Humanistic reforms in book production did not stop at text and script but extended into illumination and codicology. Earlier manufacturing techniques were revived, such as membrane prepared with a marked distinction in appearance between hair and flesh sides and ruling with a hard point instead of ink or lead point, sometimes to disastrous effect on the new medium of paper.

In addition to the scholar/antiquarian scribes there were the professional copyists (*scrittori*) who were generally fluent in both Greek and Latin, and the distressed gentlemen and schoolmasters (*copisti*) who supplemented their incomes by copying texts. Nobles such as Federigo, Duke of Urbino, might retain as many as forty *scrittori* at a time, whilst Vespasiano da Bisticci employed forty-five of them to provide Cosimo de Medici with two hundred volumes in twenty-two months.

The development of Humanistic Book Script was accompanied by that of a more slanted, cursively written variety, with some alternative letter-forms, which is known as Humanistic Cursive Book Script or Italic. It seems to have

· X ·

15

Sed tamen ista satis. refert tibi sæpe menalcas.

LY· Caufando noftros in longum ducis amores.
Et nunc omne tibi ftratum silæ æquor. & omnes
Aspice uentofi ceciderunt murmuris auræ.
Hinc adeo media eft nobis uia. nanq. sepulchrī
Incipit apparere bianoris. hic ubi denfas
Agricolæ ftringunt frondes. hic mœri canamus.
Hic hædos depone. tamen ueniemus in urbem.
Aut si nox pluuiam ne colligat. ante ueremur.
Cantantes licæ usq. minus uia lædæ eamus.
Cantantes ut eamus ego hæ te fafce leuabo.
MOE· Define plura puer. & quod nunc inftat agamus.
Carmina tum melius. cum uenerit ipse canemus.

AEGLOGA DECIMA
POETA AD GALLVM

EXTREMV hūc arethufa mihi concede laborē
Pauca meo gallo. sed quæ legat ipsa lycoris
Carmina sunt dicenda. negæ qs carmina gallo
Sic tibi cum fluctus subterlabere sicanos

Doris amara suam non intermifceat undam.
Incipe. sollicitos galli dicamus amores.
Dum tenera attondent simæ uirgulta capellæ.
Non canimus surdis. respondent omnia siluæ.
Quæ nemora aut qui uos saltus habuere puellæ
Naiades indigno cum gallus amore periræ.
Nam neq. parnafi uobis iuga. nam neq. pindi
Vlla moram fecere. neq. aoniæ aganippæ.
Illum etiam lauri etiam fleuere myricæ

A formal Humanistic Cursive Book Script, written by Bartolommeo Sanvito in the King's Virgil,
Padua or Mantua, late fifteenth century. The cursive, or Italic, tendencies are very restrained here.
BL, King's MS 24, f. 15.

6

) ſeſe' ipſam
a beatiſſimaꝫ
iquam forte'
traxerat) dilu
Genius, M u-
ſus obtulit gal
lum marram,
pugillares, ſudo
modium, curaꝫ
robarent ferme'
quidem Sponſa,
ndigna, molli ali
uiderentur mu
ſudariola, ſpecu
magis. Hinc i
rimordia prodie
thalamum con

uenirent, miſſo ad Virum libello hęc mã
dauit Jnertia, Quandoquidem ô Labor *Libellus repu-*
nos adeo contemnis: ut nec iocundiora q *dij.*
dem miſeris munera q̃ facies tua præſefe-
rat, conditione' tua non utar : Tuas igitur
res tibi habeto, tuas res tibi agito. Vale'
Labor . Ita in diuerſa noui coniuges abie- *Diuortium.*
re'. Labor ſeſe' M ineruæ' in famulatum
dedit : Peregre' proficiſci ſtatuit Inertia.
Sumptis igitur quæ' opportuna uiderẽtur,
unà Hippocriſi comite' adhibita, duabusꝗ *Hippocriſis.*
Vernulis Fraude' ac Deſidia, ꝗ ſecũ natę' *Fraus. Deſidia*
atꝗ educatæ' eſſent, peruagari orbem cœ-
pit. Ad aspectum celebris Fœminæ' concur-
rere' paſſim plenis uiɉs mortales, aſpicere'
laudare' cum formam, tum comites, circũ
ſiſtere' ſubſequi, agglomerare' ſeſe' certatim

a3

*Cancellaresca or fully developed Italic, as written by Ludovico degli Arrighi in a copy of Collenuccio's
edition of Lucian's* Apologues *and* Dialogues *commissioned for King Henry VIII of England. Rome or Flo-
rence, c. 1509–47.*
BL, Royal MS 12. C. viii. f. 6.

115

Example of Bernardo Bembo's hand from his commonplace book. The hand (or maniculum) *was a device used as a pointer or 'nota bene' (NB) sign.*
BL, Add. MS 41068A, f. D – 92.

been invented by Niccolò Niccoli by around 1420 as a rapidly written form of Humanistic Book Script. Its diffusion followed the pattern of Humanistic Book Script and it similarly inspired the early Italic typeface.

In addition to forming an elegant book script at the hands of masters such as Sanvito, Humanistic Cursive received an extra injection of panache from scribes of the Papal Chancery who added further calligraphic cursive features (such as attenuated descenders and descenders with extended head and foot strokes). They developed a script for documentary use, termed *Cancellaresca* or Humanistic Chancery Script, which in turn became, from the second quarter of the fifteenth century, a high-grade book script which we would consider to be a fully formed Italic. A key figure in this trend was Ludovico degli Arrighi who penned briefs for the Apostolic Chancery as well as luxurious tomes destined for important owners. BL, Royal MS 12.C.viii, reproduced here (*see* page 115), is a copy of the *Apologues* and *Dialogues* of the classical author Lucian, edited by Pandulfo Collenuccio of Pesaro. The text is prefaced by a letter of dedication recording that the book was commissioned (probably during the second quarter of the sixteenth century) by an English diplomat, Geoffrey Chamber, for presentation to King Henry VIII upon Chamber's return from Italy. It is written by Arrighi in a *Cancellaresca* hand associated with Rome and is decorated in Florentine style (incorporating the English royal arms on the incipit page) by the leading illuminator Attavante degli Attavanti, who also worked for the Medici and for the eminent bibliophile King Matthias Corvinus of Hungary. Arrighi also wrote the first published writing book, *La Operina*, which was printed in Rome in 1522. This illustrates variant forms of the letters of the alphabet, along with sample passages of script and is illustrated with emblems, including scribal tools.

Such was the popularity of Humanistic Cursive, or Italic, that it was soon being written with equal expertise from England to Hungary. Proficiency was often acquired through the tuition of the writing masters, either in person, or with the aid of the numerous printed writing manuals which they produced from the sixteenth century to modern times. Until supplanted by the light, linear forms of the engraved Copperplate script during the eighteenth century, Italic became the hand of the educated person of the early modern

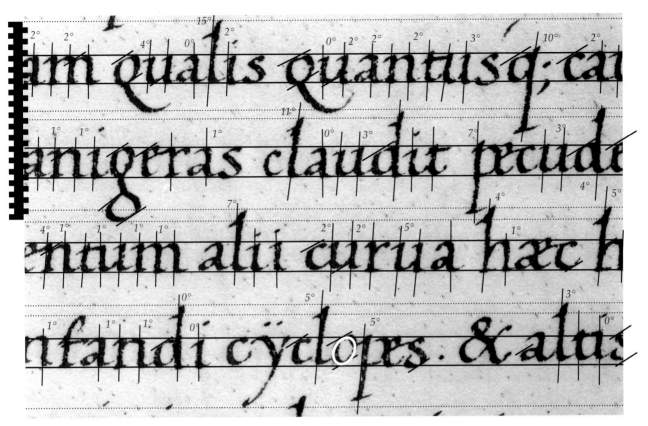

Enlargement of a formal Humanistic Cursive Book Script for analysis. This wonderfully vibrant yet very restrained alphabet style has such a consistent pen nib angle that the individual measurements for this have not been shown. The angle of slant is taken in degrees from the vertical.
BL, King's MS 24, f. 99v.

world, whether written cursively by artists such as Michelangelo or with a self-conscious meticulousness by rulers such as Elizabeth I. It can be seen written formally and informally, with equal ease, by the Paduan Bernardo Bembo (1433–1519), Venetian senator, scholar-scribe and bibliophile. He was a friend and patron to many fellow scribes, including Bartolommeo Sanvito who wrote at least four volumes for him and whom Bembo described as 'The Reverend Dominus Bartolommeo Sanvito, my honoured compatriot'. Bembo's illegitimate son, Bartolommeo, was even named after him. In turn, Bembo's patronage has led to a particular style of Humanistic Cursive, Bembo Italic, being named in his honour.

An example is reproduced here (*see* opposite) from BL, Add. MS 41068A, Bembo's Commonplace-Book which contains extracts from classical, patristic and contemporary authors, arranged alphabetically by subject, starting with *Amor* (Love). His marginal notes record Bembo's personal experiences and events from 1471–1518 and he has marked his own compositions with a '**B**' or '**BB**'. Such working books form the backdrop to the more ostentatious books produced for devotional or display purposes throughout the centuries and should be considered if an informed perspective is to be maintained concerning the historical evolution of scripts. For it is against standards of everyday handwriting that the achievements of writing as an art-form must ultimately be judged. The ordinary helps to define the exceptional, in script as in most other spheres.

Analysing the Script – *Humanistic Cursive Book Script*

There is an air of familiarity about this alphabet style because it so clearly resembles the letters we are used to reading in type. The two-compartment

Humanist

Letter height:
5 nib widths;
ascenders and
descenders
11 nib widths

Nib angle: 30°

Letter O form:
Oval

Slant: 1° – 2°

Stroke sequence:
As shown on the
exemplar letters

Speed: Moderate

Serifs: Simple entry
and exit strokes
apart from exag-
gerated entry stroke
to ascenders and
horizontal term-
inal to descenders.

Below right:
Letters which require partic-
ularly careful construction.
This hand reflects elements of
Compressed English Caroline in
*that the letters **d** and **q** are formed*
from an oval with the downstroke
added to this. This creates a rather
ugly join where the two strokes
*meet. The letter **a**, in contrast, is*
most elegant, with the bowl of the
letter starting and ending at almost
the same point on the downstroke,
creating a beautiful teardrop-
shaped counter. Unusually, the
*letter **g** is written with no last*
horizontal stroke to the right at
the top line for x-height. You may
choose to add this if you wish.

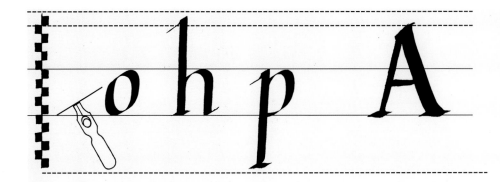

Humanist mi

letter **a** and the looped **g** are not letters which we would use in our normal handwriting, yet we read words containing them with ease because we recognise their shapes. There is a delightful fluidity about this particular extract which is not always obvious in some of the more stilted examples of Humanistic Book Script. The letters have such grace, particularly, in the enlargement, the letter **y** on the line 4 and the tails of the letters **q**. It looks as though the scribe was enjoying writing this!

The *x-height* is between 4 and 5 nib widths, which gives a lightness to the hand. *Ascenders* and *descenders* are long, well over body height at 11 nib widths or even more, as in the third letter **q** on the top line and the letter **y** on the fourth line. Their extension above and below the lines for x-height could lead to clashes as the inter-linear spaces, although these are wide at 11 nib widths, are still not wide enough for some of these elegant extensions.

The *pen nib angle* is more consistent than most of the previous alphabet styles at 30° to the horizontal, being a natural and comfortable angle at which to hold the pen.

If the *shape of the letter o* of Caroline Minuscule can be likened to a grapefruit, then that of this hand is similar in shape to a grape, being a narrow oval shape, which, with the slight forward sloping nature of this extract, produces an upright counter or white space. This gives the width of other letters and also the distinctive restrained arch shapes to the letters **r, n, m, h, b** and so on, which is reflected in the arches at the base of letters **t, u** and **l**.

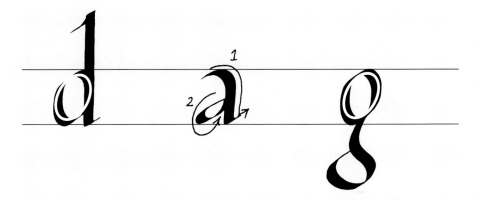

Letters which start with a downstroke

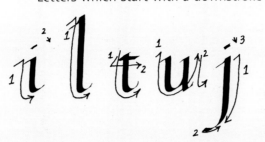

Alternative letter l, without the exaggerated starting serif. If you choose to write this letter-form, then the ascenders of all the other letters should be similar.

Letters which start with a downstroke and then arch

Letters based on the letter o

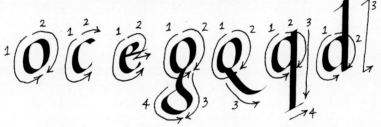

Diagonal letters

Letters which do not fit these families

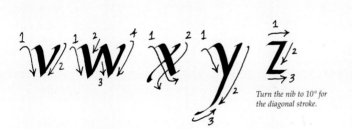

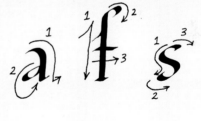

Turn the nib to 10° for the diagonal stroke.

Punctuation Ampersand Numerals

,, " " : ; ! ? - & 1234567890

abcdefghijklmnopqrstuvwxyz

Writing Humanistic Cursive Book Script.

Although many examples of Humanistic Book Script are decidedly upright, (*see* page 112) this extract shows a variety of angles of *slant*, ranging from 11° for some of the ascenders to an angle of about 1° – 2° for most strokes.

The stroke sequence is shown on the exemplar letters and reflect those of other alphabet styles.

Serifs are simple entry and exit strokes apart from those to the ascenders and descenders. A wonderfully exuberant starting stroke, not particularly close to the top of the ascenders is on the uprights, and the terminals of the descenders finish with a swift stroke to the right, with a pen held at the same angle.

The letters are carefully constructed and there are few joining strokes; there are also no elaborately constructed serifs and the comfortable pen nib angle suggests a moderate *speed*.

Analysing the Script – *developed Italic, or Cancellaresca*

The example of Italic in the enlargement shows the sort of problem which often occurs for the scribe. Here the air is formal and the writer is endeavouring to maintain a careful upright slant to the letters. But the letter shapes and the movement of the flowing strokes are leading towards a forward slant. It is almost a losing battle in some sections, the last two words on the bottom line being examples of this. This graceful and elegant alphabet style must have been welcomed by scribes in northern Europe as a dramatic change from the rigidity and compression of Gothic Book Script.

The *x-height* is between 4 and 5 nib widths, with *ascenders* and *descenders* at about 9 nib widths. *Majuscules* are between 7 and 8 nib widths.

Enlargement for analysis. Cancellaresca *or Italic, as written by Ludovico degla Arrighi in a copy of Collenuccio's edition of* Lucian's Apologues *and* Dialogues *commissioned for King Henry VIII of England. Rome or Florence,* c. 1509–47.
BL, Royal MS 12. C. viii. f. 4v.

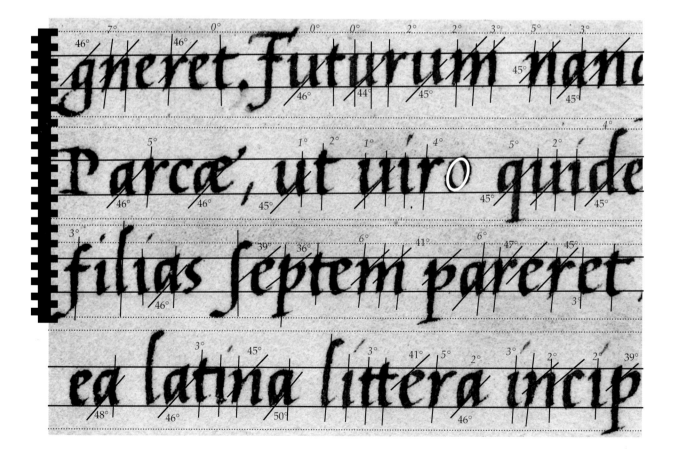

120

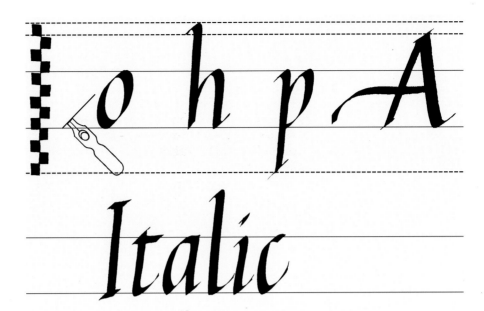

Italic

Letter height:
5 nib widths;
ascenders and
descenders
9 nib widths

Nib angle: 45°

Letter O form:
Forward slanting
oval

Slant: 5°

Stroke sequence:
As shown on the
exemplar letters

Speed: Moderate

Serifs: Simple
entry and exit
strokes apart from
extended term-
inals to ascenders.

Below right:
Letters which require particu-
larly careful construction.
*The letter **a** is the key to this*
alphabet style. The first stroke to
the left is quite a flat curve, and
this stroke is pushed right up to
the top line for x-height. By doing
this, the counter is a beautifully
smooth curve. If you stop before
you get to this top line, then the
smoothness of line is broken. Letters
***d, g, q** and **u** have similar strokes*
pushed up from the baseline. This
stroke creates a small triangular
space at the base line. This shape
and the smoothness of the curve is
*reflected in the letters **r, n, m, h,***
***p** and **b,** (and a looped **k**) where*
the arch starts from the base line
and the pen is pushed up from
there. The arch is asymmetrical,
unlike that in Caroline Minuscule.

The *pen nib angle* varies from 36° to 50°, although the average is about 45°. The *slant*, too, varies from 0° to 7° averaging at about 4°. A slant of 5° will produce letters where the counter, or white space, to letters based on the oval letter **o** is upright.

The *letter o* is a forward slanting oval, and forms the shape for the wonderfully springing arches which are characteristic of this hand. The arch shape on letters such as **r, n, m, h, b, p** and **k** moves away from the downstroke about halfway between the two lines for x-height. Their shape is asymmetrical, unlike the arch shapes on Caroline Minuscule – which are symmetrical. This leaves a small triangular counter, white space, between the arch and the downstroke. This same shape is repeated at the base of letters such as **a, d, u, q** and a **y** based on the letter **u**, where this time the stroke is pushed up from the bottom line for x-height, against the resistance of the pen. When writing this stroke, lift the pressure from the pen so that it is almost dancing over the surface of the paper. If you have a heavy hand though, the nib will spray ink. It is one of the most satisfying strokes in calligraphy when it works.

The *stroke sequence* is shown on the exemplar letters.

Serifs on most letters are simple entry and exit strokes. However there are extended terminals to the right on ascenders, and a simple horizontal serif finishing off the terminals of the letters **p** and **q**.

Because there are no complicated serifs to construct, fewer pen lifts than with many other hands, a natural pen nib angle for the hand to maintain and a slightly forward slope, the *speed* at which Italic letters are written is moderate.

Had we but world enough, and time,
This coyness, Lady, were no crime.
We would sit down, and think which way
To walk, and pass our long love's day.
Thou by the Indian Ganges' side
Should'st rubies find: I by the tide
Of Humber would complain. I would
Love you ten years before the flood:
And you should, if you please, refuse
Till the conversion of the Jews.
My vegetable love should grow
Vaster than empires, and more slow.

Formal Humanistic Cursive Book Script seems, despite elements of grandeur, an elegant and romantic writing style. What better hand to use for the opening lines of Andrew Marvell's To his Coy Mistress, *in a romantic shade of pink, with a pink pastel background.*

The year takes on a change of tense:
low angles of the light
a few leaves
FALLING,
their dappled lilt
a counterpoint to commonsense.
We know the longer nights
will soon be coming
and yet, air bright
TWIG-STILL,
an acorn's rapid fall
suggests new life not death
while bracken, drawing
A MID-DAY BREATH
hums a wing-lit madrigal
as midges from their sloth
LIFT: A LAST SUNNING
above cool earth.

The Italic writing style has a surprisingly up-to-date feel and many scribes use it for modern writings. This poem, October, by Ted Walter suits the hand, and autumnal colours have been used both in the background and in the pen to create the appropriate mood .

Letters which start with a downstroke

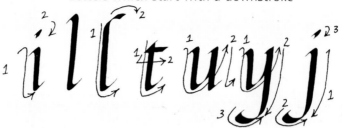

Use the simple starting stre
a serif, or the more formal s
to the right, shown on the a
native letter **l** here. Whiche
one you choose, make your
consistent.

Letters which start with a downstroke and then arch

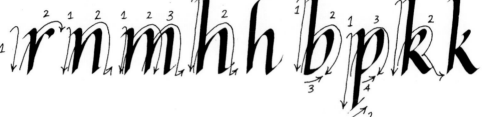

Letters which start with a stroke to the left

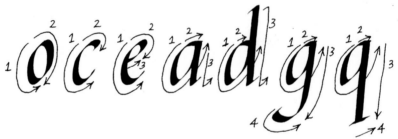

Diagonal letters

Letters which do not fit these families

Ct ligature

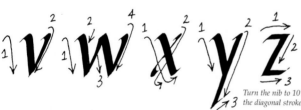

Turn the nib to 10° for the diagonal stroke.

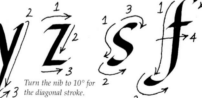

*This ligature can be used to join the letters **c** and **t**. A similar ligature can be used to join the letter **s** and **t**.*

Punctuation

Ampersands

Numerals

, : " .: : ! ? ~ & & 1 2 3 4 5 6 7 8 9 0

a b c d e f g h i j k k l m n o p q r s t u v w x y z

Writing Italic.

124

A A A A A A A A B B B B

C C D D D E E E F F

G G G H H H H H H I I J J

K K L L L M M M M

N N N N O P P P Q Q

Q R R R R S S T T T

U U U U V V V W W W

X X X Y Y Y Z Z Z

& & & &

Flourished capital letters to use with Italics for a formal piece of work. Use these flourished letters sparingly.

Further Information

Calligraphy and lettering are popular enthusiasms, and there are many local and regional groups throughout the world. Look in a telephone directory or ask in a library or city hall for details of lettering activities within your area. National/International societies are listed below.

Calligraphy and Lettering Arts Society
54 BOILEAU ROAD, LONDON SW13 9BL, UK.
For beginners to professionals, a full range of educational activities, programme of meetings, lectures, workshops and courses. Bi-monthly magazine.

LETTERS
HERNEWOOD, GRACIOUS LANE, SEVENOAKS, KENT TN13 1TJ, UK.
For children and young people interested in all forms of letters and lettering. Newsletter three times a year, competitions and special offers.

Society of Scribes and Illuminators
C/O 6 QUEEN SQUARE, LONDON WC1N 3AR.
Workshops and lectures. Twice yearly magazine.

Further reading

Historical manuscripts

Janet Backhouse, **The Illuminated Page,** *1997*
Bernhard Bischoff, **Latin Palaeography,** *English edn, 1989*
Leonard Boyle, **Medieval Latin Palaeography: a Bibliographical Introduction,** *1984*
Michelle P. Brown, **A Guide to Western Historical Scripts from Antiquity to 1600,** *1993*
Michelle P. Brown, **Understanding Illuminated Manuscripts, a Guide to Technical Terms,** *1994*
Michelle P. Brown, **The British Library Guide to Writing and Scripts,** *1998*
Christopher de Hamel, **Scribes and Illuminators,** *1992*
Donald Jackson, **The Story of Writing,** *1981*
Stan Knight, **Historical Scripts,** *1984, 1998*
James Wardrop, **The Script of Humanism,** *1963*

Calligraphy and Lettering

Ann Camp, **Pen Lettering,** *1984*
Heather Child, **Calligraphy Today,** *1988*
Heather Child (Editor), **The Calligrapher's Handbook,** *1985*
Gaynor Goffe and Anna Ravenscroft, **Calligraphy Step by Step,** *1994*
Gaynor Goffe, **Calligraphy Made Easy,** *1994*
Michael Gullick, **Calligraphy,** *1995*
Susanne Haines, **The Calligrapher's Project Book,** *1987*
Peter Halliday, **Calligraphy Masterclass,** *1990*
Peter Halliday, **Calligraphy – Art & Colour,** *1994*
David Harris, **The Art of Calligraphy,** *1995*
Michael Harvey, **Creative Lettering Today,** *1995*
Edward Johnston, **Writing, Illuminating and Lettering,** *1906; reptd, 1977*
Patricia Lovett, **Calligraphy for Starters,** *book 1995, video 1996*
Patricia Lovett and Rosemary Sassoon, **Creating Letterforms,** *1992*
Patricia Lovett and Fiona Watt, **Starting Lettering,** *1996*
Patricia Lovett, **Teach Yourself Calligraphy,** *1993*
Patricia Lovett, **Tools and Materials for Calligraphy, Illumination and Miniature Painting,** *1996*
Charles Pearce, **The Little Manual of Calligraphy,** *1982*
Satwinder Sehmi, **Calligraphy – the Rhythm of Writing,** *1987*

Index